GRAPHIC ORIGINALS

RotoVision

GRAPHIC ORIGINALS

DESIGNERS WHO WORK BEYOND THE BRIEF

JANE AUSTIN

A RotoVision Book
Published and distributed by RotoVision SA
Rue du Bugnon 7

RotoVision SA
Route Suisse 9, CH-1295 Mies, Switzerland

RotoVision SA, Sales & Production Office
Sheridan House, 112/116A Western Road
Hove, East Sussex, BN3 1DD, UK

Tel: +44(0)1273 727 268
Fax: +44(0)1273 727 269

E-mail: sales@rotovision.com
Website: www.rotovision.com

10 9 8 7 6 5 4 3 2 1

ISBN 2-88046-706-3

Commissioning editor **Kate Noël-Paton**
Design by **HDR Visual Communication**

Production and separations in Singapore by
Provision Pte. Ltd.

Tel: +65 334 7720
Fax: +65 334 7721

Contents

Graphic Originals considers how and why designers, from recent graduates to established corporate design consultancies, are self-initiating graphic elements – including illustration, typography, photography and specially written software for digital media – to produce unique design. Such self-initiated design elements can form a strong part of a designer's and client's overall message. It offers a fresh perspective and a bespoke solution that often produces more effective results than if the work had been freelanced out.

This book profiles designers who use their craft skills and imagination to create unique but marketable work. It explores how individuality and uniqueness can play a part in work produced for a client, even if the finished product doesn't contain all the designer's own content. It reveals that self-initiated and original elements lead towards design that avoids the derivative and the clichéd. The profiles examine the designers' practical approaches and general attitudes towards graphic design, self-initiation and notions of authorship within the confines of commissioned work. These designers devise a unique visual solution to a problem that is not only effective, but makes them feel like a co-creator; they produce work that expands the traditional boundaries of graphic design.

The first section of the book features designers who specialise in creating their own graphic elements in a variety of disciplines. They are new designers, freelancers and small non-mainstream operations.

The second section profiles established designers who work with their clients to develop briefs from concept stage. These designers are notable for their ability to retain long-term client relationships, achieve economic success and yet produce designs that feature elements of self-initiation and ingenuity, whether in choice of medium or content.

The final section examines how strong and individual work can be achieved even on projects that require the adaptation of existing work, such as corporate identity redesigns.

The 'spreading out' into other oeuvres is not a new feature of the world of graphic design. Herbert Bayer, Charles and Ray Eames and Tibor Kalman were all designers who worked beyond both the brief and the medium.

Introduction

However, recent factors have increased interest in self-initiation: innovations in technology; similar trends within contemporary art and graphic design; and the maturing of the design industry – designers are now more confident and feel on an equal footing with clients in business.

Technical innovation has greatly changed graphic design in the last 20 years. Graphic design crafts have become easier to execute, and designers can produce more diverse types of work. In many cases, this has led to a plethora of meaningless design that says more about the designer's knowledge of technology than it does about craft, thought and purpose. More positively, though, technological advancements have encouraged greater creativity. The cross-pollination of design disciplines has encouraged a DIY attitude towards the elements of graphic design. Designers realise that technology is only a tool, and one that is responsible for much of the ground-breaking work showcased here.

A further result of technological innovation has been the transferral of production from crafts- and tradespeople to the desktop of the designer. While this gives the designer more control, it also takes 'creative' time away from the designer and replaces it with production responsibilities. Have these technological advancements (which limit the need to outsource), combined with the present economic downturn, further compelled designers to self-initiate their own graphic elements? It might also be said that technological developments have allowed designers a new platform for experimentation and original authorship. Integrated media skills have also furthered a manufacturing, and, consequently, a marketing base for designers.

Technological developments have forced a reassessment of what graphic designers actually do. As Steven Heller says in his essay *The Attack of the Designer Authorpreneur*: "Today there are two kinds of graphic designer. One is primarily production orientated, the other primarily idea orientated. Although the two are not mutually exclusive, one by-product of the digital revolution is a clearer distinction between those with skill and those with imagination." Tension has arisen between two notions of design excellence: the originality of design and the reproduction of the product.

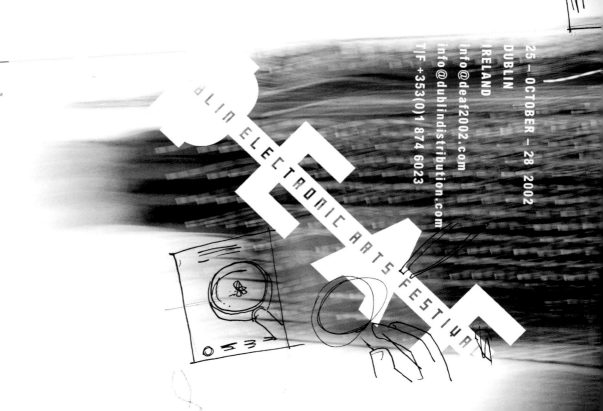

DUBLIN ELECTRONIC ARTS FESTIVAL

25 — OCTOBER — 28 2002
DUBLIN
IRELAND
info@deaf2002.com
info@dublindistribution.com
T/F +353(0)1 874 6023

As Max Bruinsma says in his essay *The World Must Change – Graphic Design and Idealism*: "If a design is reproduced in surroundings which may go very much against the designer's vision, what then is the value of that vision? Or what is wrong with the reproduction channels if the reproduction refuses to stick to the design...? Design can be realised in more ways than one and still be 'original'. What matters then is that the design indicates a possibility, an as yet unrealised way of tackling a problem. Designers seem to exult in individuality as if in a last up-welling of self-expression before everything is finally absorbed into a pool of existing images and languages."

A central theme of this book is the questioning of the notion of authorship. Is 'authorship', as Steven Heller says: "The new buzzword for intellectual graphic designers looking for new ways to broaden the scope and increase the relevance of their cultural contributions ... Authorship is a redistribution of graphic designers' talents and energies in a product-orientated rather than service-orientated arena. Authorship is more than 'mutation': it allows the graphic designer to have a larger, and more accepted, role in popular and commercial cultures."

Alternatively, Rick Poyner states: "If they [designers] want to engage and enlighten others, graphic authors need – just like any author – to have pressing, original or penetrating observations to make about their experiences of the world and the conviction to express them in public."

'Graphic authorship' offers a number of definitions, but for most designers, who work for commercial clients, the term is a misnomer: the term 'author' indicates that the originator has complete control over the content of the work, and this rarely occurs when a designer is being paid to serve a client's commercial interests. In this situation, does a designer have the right to communicate his or her own message through a paid-for piece of design?

The consensus from the designers interviewed for this book is that commentators from outside the design industry give far more credence to the authorship debate than designers. Design is traditionally a market-driven service industry, and the notion of being 'the author' – especially for corporate work – rarely enters designers' heads. Most designers in this

Vertical & horizontal axis.

book view themselves as the author in their personal work, but not in their commercial work. They want to be seen as the originator of a unique idea, or a co-creator or an editor of content. The term 'author' is reserved for authors of books or for artists, who originate ideas or forms without answering a client's problem.

While many designers refute the notion of authorship in fee-paying work, it is notable that many designers feel the need to produce 'original' and 'individual' work (especially in typography) in this post-modern culture where resampling of existing forms is the norm. Indeed, the growing momentum of the graphic authorship debate illustrates how designers with ideas, as opposed to style and form, are striving to find an 'appropriate' voice in a consumer- and product-led society – or at least produce work that is truly original.

The 'authorship debate' has encouraged a new way of thinking that is the result of the design industry's reaching maturity as a business. There is a confidence, expressed by many of the designers featured here, that they can make creative choices: witness Stefan Sagmeister's year off without clients and Golan Levin's mode of cherry-picking clients who seek him out after seeing his personal work online. Accordingly, is 'graphic authorship' a correct term for such work? Is there room for a new agenda for designers who want to originate within commercial constraints, as opposed to those who wish to challenge the relationship between artist/designer and patron? Make way for the 'graphic originals'.

```
((mode == MODE_TRAIL) || ((mode == MODE_LOGO) &&
    // draw the trailing diamond
    vh = (float)(Math.sqrt(vx*vx+vy*vy));
    if (vh > MIN_VELOCITY){

        wxh = vxh;
        wyh = vyh;
        vxh = size*vx/vh;
        vyh = size*vy/vh;
        vwx = (wxh + vxh)*0.5f;
        vwy = (wyh + vyh)*0.5f;

        xpts[0] = (int) (px + wxh*2.0f);
        ypts[0] = (int) (py + wyh*2.0f);
        xpts[1] = (int) (px - vwy);
        ypts[1] = (int) (py + vwx);

        xpts[2] = (int) (px - vxh*2.0f);
        ypts[2] = (int) (py - vyh*2.0f);
        xpts[3] = (int) (px + vwy);
        ypts[3] = (int) (py - vwx);
```

1

In this first chapter, we consider the work of young designers who are less established than those featured elsewhere in the book. These designers are both relatively recent graduates and up-and-coming businesspeople, who are still finding their place in the design community and striving to win clients, while simultaneously pushing their creative agendas.

What unites the designers in this section is the desire to forge long-term relationships with their clients that allow their work to be different and personal. This type of designer-client relationship provides the opportunity to take a more experimental approach and gives the designer the confidence to include personal work that might otherwise be commissioned from illustrators, photographers, typographers or coders. This use of personal work, where the designer self-initiates one or more elements, may serve several purposes: to cut costs; to have more control over the design process and resulting work; and to help produce a distinctive style.

Many of the designers in this chapter also produce self-initiated design where they are both client and creator. This enables them to express the creative originality that the freedom of a college environment allowed them to cultivate. Such projects, as in the cases of Golan Levin, Sara Fanelli, Niall Sweeney and Bark, also provide inspiration for commissioned projects and act as new business calling cards.

Personal design ventures, some may argue, challenge the seemingly ever-decreasing divide between design and art. However, few of the designers interviewed in this chapter see their work – personal or commissioned – as provoking the design/art distinction in this way. While they see their work as exploratory and possibly 'authored' by themselves, the language used is that of the designer. Where art has no client, designers' personal work is often created by designer as client. The work is intended to be design, but design unequivocated by external influence. This allows the designer to experiment freely within the recognised structures of the discipline, using self-initiated elements.

These personal projects, such as Golan Levin's 'Meshy' – which led to the winning of a commission for BP – together with creating one's own typography or photography for a commission, serve to keep the creative spirit alive while coping with budgets, schedules and erratic workloads.

Many of these young designers prefer to work with clients who are design literate and who respect them for their individuality. In this case, there is a battle between making a good living and maintaining creative integrity. Says Levin: "I barely make a living doing what I do. It's just that this is the only way that I know how to work, and it's the only way that I find interesting and worthwhile."

Young designers

Sara Fanelli is one of the few featured designers in this chapter who has found accepted status as an artist: "It's nice to be commissioned by design-literate clients who like what I do and have respect for me as an artist, but also have the confidence that I will fulfil their brief and create something new especially for them."

It is almost a rule of thumb that design-literate clients rarely have a generous budget. Both Fanelli and Levin refute that because of the self-initiated nature of their work they are a cheaper option for clients – they just prefer more creative briefs and greater freedom.

Working for less money, for companies such as NB:Studio who operate in the more traditional design consultancy structure, requires being more careful of commissioning out work. The designers self-initiated their own illustrations for their award-winning poster designs for Knoll. According to the design team, it made more sense for them to do it themselves because, "as we created the design and the brief, we knew exactly what we wanted".

Technological innovation means that cross-disciplinary work is practical and accessible, as well as being cheaper, for those who prefer to retain total control. This new generation of designers is familiar with many contemporary mediums and can push them to their limits to create innovative and appropriate solutions. Witness Bark's use of a digital camera to create a 'documentary' of Portsmouth Polytechnic, and Language's self-penned script and use of film post-production techniques to create a film for broadcaster RTE.

Ultimately, computers, cameras and software are only tools. It is a measure of a designer's creative integrity to see how he or she can use them to produce original work and broaden their skills rather than merely to speed up the design process. Niall Sweeney states: "Like my knowledge of print and ink, I understand coding for animation and video on the machine. To engage with the machine, whatever form it takes, is completely satisfying."

The medium is just a means to an end, and the more means a designer has – whether these are traditional craft skills or an understanding of computer code – the more creative they can be.

REGISTRATION AND
PATENT PENDING

**Nick Finney, Alan Dye and Ben Stott of
NB:Studio, London**

Since 1998, London-based design company
NB:Studio has frequently worked with leading
furniture designer and manufacturer Knoll. Most
of NB:Studio's work for Knoll has involved the
design team self-initiating bespoke illustration for
an ongoing print, press and poster campaign that
is unique to the brand and that maintains its
design heritage.

Knoll came to NB:Studio through recommendation
from an ex-colleague who had designed several
pieces of furniture for them. According to Finney:
"Our first big job as a company was a sales
brochure for a new Knoll furniture range. It was
well received by the client, who gave us the chance
to experiment with the work we did afterwards.
We proved ourselves as professional designers, so
from then on we have almost been left to our own
devices with Knoll. We have a 99 per cent success
rate with the designs we present, and we pretty
much create the brief with them."

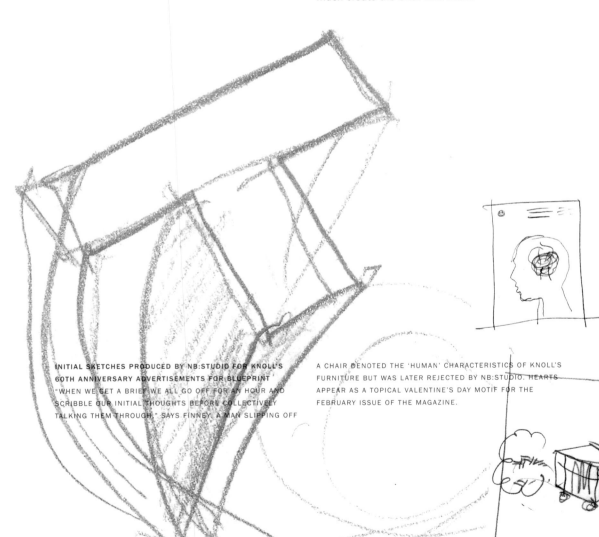

INITIAL SKETCHES PRODUCED BY NB:STUDIO FOR KNOLL'S
60TH ANNIVERSARY ADVERTISEMENTS FOR BLUEPRINT.
"WHEN WE GET A BRIEF WE ALL GO OFF FOR AN HOUR AND
SCRIBBLE OUR INITIAL THOUGHTS BEFORE COLLECTIVELY
TALKING THEM THROUGH," SAYS FINNEY. A MAN SLIPPING OFF

A CHAIR DENOTED THE 'HUMAN' CHARACTERISTICS OF KNOLL'S
FURNITURE BUT WAS LATER REJECTED BY NB:STUDIO. HEARTS
APPEAR AS A TOPICAL VALENTINE'S DAY MOTIF FOR THE
FEBRUARY ISSUE OF THE MAGAZINE.

NB:Studio

NB:Studio has created illustrations for two successful Knoll projects. The first campaign was a series of 12 ads that appeared over the period of a year in *Blueprint* magazine to celebrate 60 years of the brand. The design team chose illustration over photography because most advertisements in the periodical feature lifestyle or product photos. Illustration, they felt, would make their client stand out more.

Dye explains: "We literally had to create the ads overnight, so we really had no choice but to create the images ourselves. Also it seemed natural for us to execute the idea after having visually realised it – it was the way of making the overall design work most effectively."

Finney continues: "Why ask someone to draw something that you've just thought up? If we had used somebody else it would have been a technical illustrator. We would have felt as if we hadn't done anything if we'd got an illustrator in. It's like if you commission fantastic photography; as a designer all you do is crop the pictures.

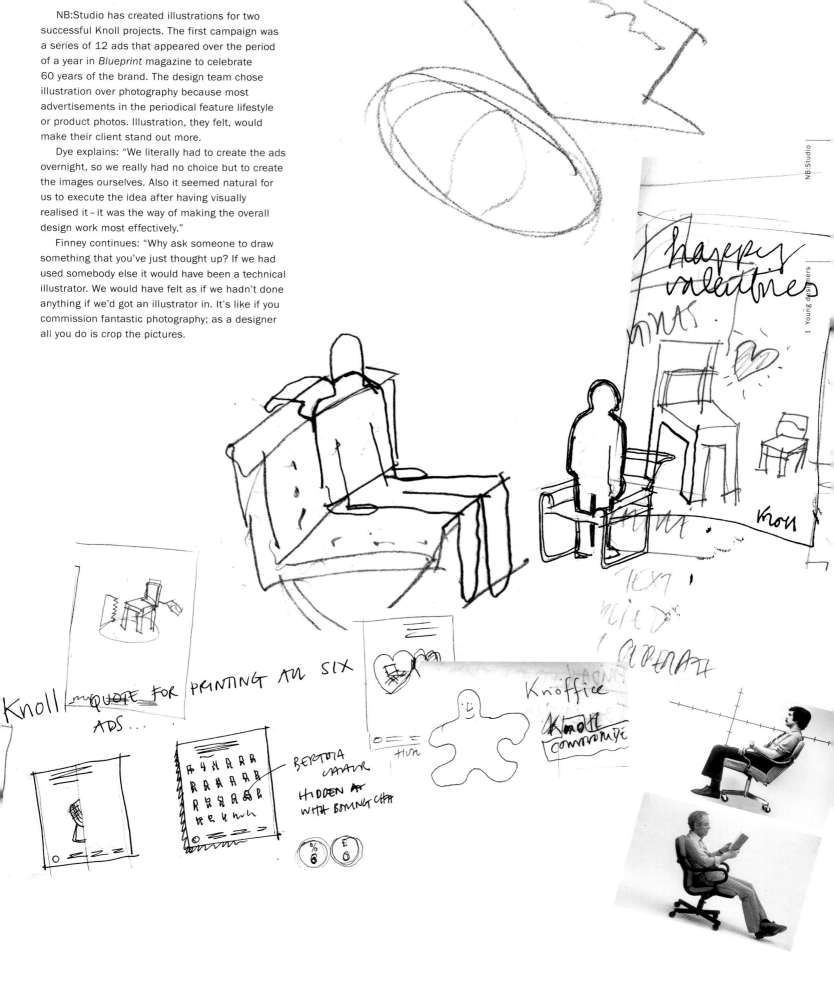

If you're a good designer you should be able to self-initiate; the process is part of being hands-on."

NB:Studio sourced the quotations featured at the top of each ad from an existing Knoll brochure and developed the visual idea from that source. They traced photographs of actual chairs from archived Knoll catalogues, which were fed into Illustrator and Photoshop to allow manipulation of the sketches.

Adds Stott: "We think that the overall design is a better and a stronger project because we undertook the illustration: we played a more integral part in the process and took total control. The designer in this case was both the art director and the illustrator, so it was possible to achieve exactly what we wanted."

"If you're a good designer you should be able to self-initiate; the process is part of being hands-on."

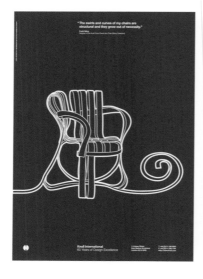

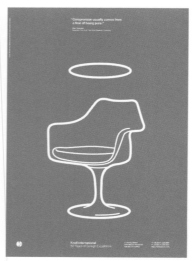

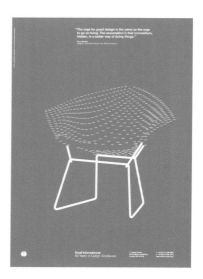

ACTUAL ADS AND POSTER FOR KNOLL'S 60TH ANNIVERSARY, 1999 THE CHOICE OF FLAT, MUTED COLOURS WAS INSPIRED BY A CHILDREN'S BOOK BY J OTTO SIEBOLD. THE MAN FEATURED IN ONE OF THE POSTERS WAS TRACED FROM KNOLL'S DESIGN BOOK AND APPROPRIATED IN PHOTOSHOP AND ILLUSTRATOR. THE SERIES OF ADS PROVED POPULAR, SO KNOLL ASKED NB:STUDIO TO PRODUCE THEM AS POSTERS FOR PROMOTIONAL PURPOSES.

"In the end we shall sit on
resilient columns of air."

Marcel Breuer
Designer of the Knoll Wassily Chair (Breuer Collection)

Knoll International
60 Years of Design Excellence

1 Lindsey Street
East Market Smithfield
London EC1A 9PQ

T +44 [0]171 236 6655
F +44 [0]171 248 1744
http://www.knoll.com

The second project for Knoll, a series of 40 posters, was for an exhibition entitled 'Spectrum' to promote a range of furniture. The brief was very open: "We need something to go on the walls." Again, there was a tight turnaround period.

NB:Studio researched the project by examining Knoll's archived, printed, visual material. They found inspiration in an old document about the future of office working. Using a combination of digital photography, found images and illustration, they created a series of posters that drew on the client's culture and heritage, repositioning it in a fresh, contemporary and witty way.

NB:Studio found the typewriter in an Army & Navy catalogue from the thirties, while the hand was taken from a piece of design created by Herbert Matters in the fifties. This illustration, along with the hand-drawn plug, was created in Photoshop and Illustrator.

Finney believes that clients don't care whether designers self-initiate their own elements or not. "All they are interested in," he explains, "is that the job gets done and to their budget." He adds: "The material benefit to them if we self-initiate is that they don't have to pay us a repeat fee if they decide to use the illustration or photograph elsewhere. We don't have to deal with agents, as we are our own agents; so the self-initiation of elements makes us, as a design group, really adaptable."

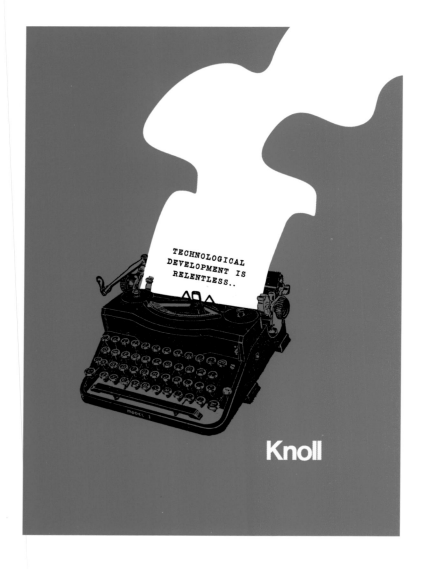

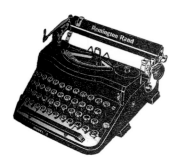

SPECTRUM POSTERS: TYPEWRITER (ABOVE), HAND, AND PLUG (FAR RIGHT), 2000
THE TYPEWRITER WAS FOUND IN A THIRTIES ARMY AND NAVY CATALOGUE, WHILE NB:STUDIO DREW THE PLUG. THE HAND WAS FROM AN ORIGINAL HERBERT MATTER DESIGN. NB:STUDIO SCANNED THE IMAGE AND CHANGED BOTH THE TYPE AND WORDS TO REFLECT SPECTRUM.

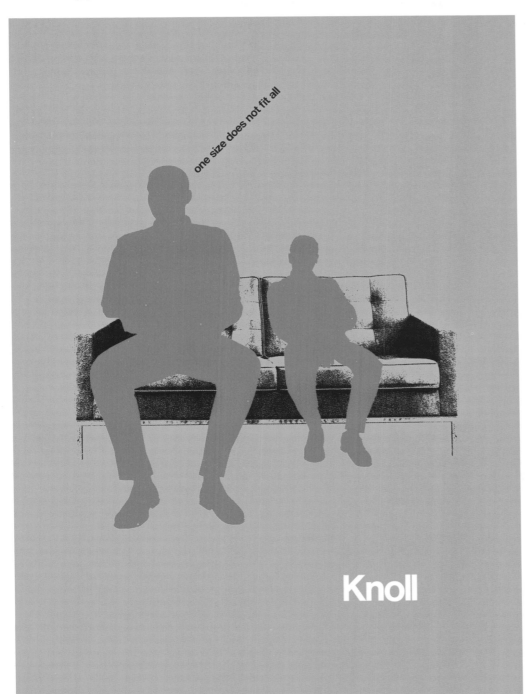

one size does not fit all

Knoll

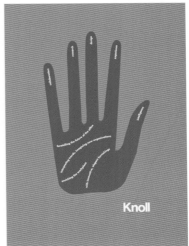

Knoll

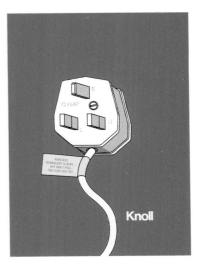

Knoll

SPECTRUM POSTER: ANONYMOUS MEN ON SOFA
THE DESIGN TEAM TRACED AROUND A PICTURE OF TWO MEN
FROM A MAGAZINE, SHRUNK THEM DOWN, FLIPPED THEM
AROUND AND RE-DREW THE OUTLINE SO THAT NEITHER THE
MODELS NOR THE MAGAZINE WOULD BE ABLE TO RECOGNISE
THE ORIGINAL SOURCE. BOTH THE MEN ON THE FLORENCE

KNOLL SOFA WERE TREATED SO THAT THEY WERE
UNIDENTIFIABLE. "THE BEAUTY OF SELF-INITIATED WORK IS
THE WAY YOU CAN ADJUST EXISTING WORK TO DEVELOP AN
ILLUSTRATION OR DESIGN FOR A CLIENT WHICH IS UNIQUE
AND COST-EFFECTIVE," SAYS FINNEY.

post-post

James Goggin of Practise, New Zealand

James Goggin's self-initiated elements include photography, illustration and font creation. Sometimes he uses all three at once. Since he views most modern fonts unfavourably, Goggin tends to create his own. He bemoans the ubiquitous use of some 'trendy' fonts, which quickly fall out of date. "I don't like the way that many contemporary fonts are over-designed," he explains. "Even worse is the way designers and advertising agencies utilise supposedly cool fonts in an attempt to instantly make their work look cutting-edge rather than taking a more original approach with the content."

"I always have a picture in my head of which typography would suit the design best," he continues. "Most of my fonts are quite subtle, and often go unnoticed by the reader as I normally make simple, utilitarian typefaces which are fully legible yet somehow odd and slightly different. I created a sans-serif version of Courier while at college to circumvent the Courier-only rule of a first year typography exercise. I actually got marked down for using it because it looked different enough from Courier to seem like I was completely

POST TYPEFACE, 1999

WHILE GOGGIN'S PARENTS WERE LIVING IN INDIA, A LETTER TO HIS FATHER WAS MISTAKENLY REDIRECTED TO GOGGIN. ON THE ENVELOPE HE DISCOVERED AN INTERESTING UTILITARIAN TYPEFACE; AN INCOMPLETE ALPHABET ACTING AS A KIND OF POSTAL SYSTEM CODE, SEEMINGLY TO BE CROSSED OUT OR

LEFT UNTOUCHED AS NECESSARY. GOGGIN WAS DESIGNING A CATALOGUE FOR THE FASHION DESIGN DEPARTMENT AT THE ROYAL COLLEGE OF ART IN LONDON AT THE TIME, AND DECIDED TO SCAN IN THE ALPHABET AND COMPLETE THE CHARACTER SET HIMSELF SO AS TO HAVE A NICE SIMPLE MACHINE-LIKE TYPEFACE TO USE.

HE DESIGNED THE CATALOGUE TO BE VERY CLEAN AND SPARSE, TO AVOID INTERFERENCE WITH THE STUDENTS' DESIGNS AND THE FASHION PHOTOGRAPHY. THE STUDENT INFORMATION WAS TYPESET IN THE NEW FONT, NAMED POST, WITH ALL DETAILS SET AT MORE OR LESS THE SAME SIZE, RESULTING IN A MATTER-OF-FACT BUT SLIGHTLY ODD-LOOKING AESTHETIC.

James Goggin

breaking their rules. Once I explained what it actually was, however, I think I made things worse! They didn't think I was taking the project seriously, but I was merely attempting to answer the brief in a different way."

Courier Sans was initially designed in 1994 and subsequently rediscovered by Goggin in 1999. It has since been redrawn in regular and bold weights and is on sale through www.lineto.com. He has used the font in commissioned work for clients such as Booth-Clibborn Editions and his own All-Weather clothing label.

Goggin created the Sample font in 2001. This is a mono-spaced typeface partly derived from a dot matrix-printed invoice from a French textile company. Although the matrix was smoothed to produce clean characters, idiosyncrasies such as the compressed descenders were left untouched. This face was also used on a project for Booth-Clibborn Editions, and Goggin is currently fine-tuning it for release in 2002.

SAMPLE TYPEFACE, 2001
ALTHOUGH THE DOT MATRIX LOOKED NICE, GOGGIN SAW THE POTENTIAL FOR A FUNCTIONAL MONO-SPACED TEXT FONT ONCE THE DOTS WERE JOINED AND CONVERTED INTO SMOOTHED LETTERFORMS. HE SUBSEQUENTLY USED THE ALMOST-FINISHED FONT, NAMED SAMPLE AFTER THE TEXTILE SAMPLE HE WAS BEING INVOICED FOR, ON A CATALOGUE FOR BOOTH-CLIBBORN EDITIONS.

Goggin runs a womenswear label with his fashion designer wife, Shan, under the name Shan James. For the outfit's identity Goggin used his Staedtler 982 font, inspired by both German and Japanese stencils, and his own handwriting.

"I enjoy taking my own photographs and creating fonts for my work but I'd like to stress that I still love collaborating with interesting people, too," comments Goggin. "To a certain extent it makes the process more exciting. There can be a danger of thinking that you can always do everything yourself and if you don't take the opportunity to commission other illustrators, photographers or writers sometimes, you are really missing out. Graphic designers can benefit from working with others by having people from different disciplines question why they do things in a certain way."

Goggin stresses that it is imperative that the designer is self-critical and aware of what she or he is doing at all times. "Many designers create a signature style for themselves that can easily start to look one-dimensional. The work in question becomes a signature piece by the designer, instead of the writer or artist whose work the designer is dealing with. I can't understand designers applying the same style to many different projects," he explains. "As a designer I invariably create work that can be recognisable at times but this doesn't necessarily apply to the aesthetic – it can also be about the thought process and how I deal with and refer to the content. Designers have a duty to make content more accessible but this can be dealt with in many different ways. I aim to never reapply the same look to different jobs. If it is a book, for example, I take inspiration from the writing, and from the context I know the book will be placed in. The client's material often prescribes a certain route to take with aesthetics and materials and provides different and new ways of educating oneself. A designer needs to understand and know the content so that she or he can strike the balance of contributing to the subject at hand, but not intrude on it."

Goggin believes that any debate that provokes designers to question their work is a positive step in encouraging more thoughtful design, although he has reservations about some of the

SHAN JAMES
148 STOKE NEWINGTON CHURCH STREET
LONDON N16 OJU

SHAN CONNELL

T/F +44 (0)20 7254 9507
M +44 (0)7977 047 377
E SHAN@SHANJAMES.COM

WWW.SHANJAMES.COM

............................*
....................**** SIZE..................

*****.**** SHAN JAMES

"Graphic designers can benefit from working with others by having people from different disciplines question why they do things in a certain way."

SHAN JAMES IDENTITY, 2000
SHAN JAMES IS THE FASHION COMPANY OWNED BY GOGGIN AND HIS WIFE. FOR ITS IDENTITY, THE REQUIRED INFORMATION FOR LETTERHEAD, BUSINESS CARD AND SWING TAG ARE PLACED IN A SIMPLE RANGE-LEFT SAME-SIZE CONFIGURATION, BUT ARE COMPLICATED ON THE REVERSE OF EACH WHERE THE FACTUAL BECOMES A JUMBLE OF RANDOMLY COLOURED ASTERISKS, PRECISELY MIRRORING THE TEXT ON THE FRONT. THIS BACK/FRONT TREATMENT OF THE TYPOGRAPHY BECOMES THE IDENTITY IN ITSELF, A RECOGNISABLE SYSTEM ESCHEWING THE NEED FOR A TIDY LOGO OR LIMITED COLOUR PALETTE.

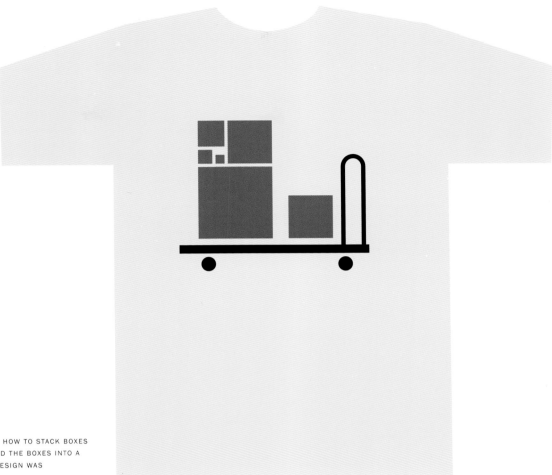

GOLDEN BOXES T-SHIRT, 2002
USING AN INSTRUCTION DIAGRAM ON HOW TO STACK BOXES
FOUND AT IKEA, GOGGIN REARRANGED THE BOXES INTO A
GOLDEN SECTION FORMATION. THE DESIGN WAS
SCREENPRINTED ONTO THE T-SHIRT.

NEW PARENT SWEATSHIRT, 2002
THE WHITE SCREENPRINTED SHAPE APPLIED TO THE
SHOULDER ECHOES NECESSARY CLOTHING PROTECTION FROM
NEWBORNS IN A VERY SIMPLE AND WITTY WAY.

ASTERISK T-SHIRT, 2002
IN 2002, DUE TO WORK AND FAMILY COMMITMENTS, GOGGIN
HAS BEEN TRAVELLING BACK AND FORTH BETWEEN NEW
ZEALAND AND LONDON. IN NEW ZEALAND, THE WORK OF SIGN-
WRITERS IS STILL HIGHLY VISIBLE AND COMMONPLACE IN
COMPARISON TO LONDON, AS INCONGRUOUS FRILLY
DECORATIONS ON INTER-CITY SEMI-TRAILERS, ON SIGNAGE
AND, IN PARTICULAR, ON SHOP WINDOWS. CONSEQUENTLY,
GOGGIN HAS PHOTOGRAPHED FLUORESCENT 'SALE' STARBURSTS
AND ASTERISKS PAINTED ON SHOP WINDOWS AS HE TRAVELS,
AND DEVELOPED THE IDEA OF COMMISSIONING A SIGN-WRITER
TO PAINT ONE ON A T-SHIRT.

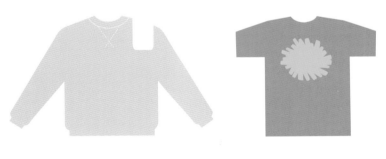

ALL-WEATHER CLOTHING LABEL, 1998–2002
OVER THE LAST FEW YEARS, GOGGIN HAS KEPT A FOLDER ON
HIS HARD DRIVE WITH RANDOM IDEAS FOR T-SHIRTS, LOGOS,
ALTERED FOUND OBJECTS AND COLLABORATIVE EPS FILES
SENT BACK AND FORTH BETWEEN HIM AND HIS FRIENDS.
GOGGIN HAD GRADUALLY STARTED TO CREATE PRINT DESIGNS
FOR T-SHIRTS ON HIS WIFE'S WOMENSWEAR LABEL, SHAN JAMES.
TOGETHER THEY REALISED THAT WITH ALL THE RESEARCH THEY
HAD DONE INTO FINDING GOOD SCREENPRINTERS, A T-SHIRT
MANUFACTURER, AND QUALITY 100 PER CENT COTTON SWEAT-

SHIRTING, GOGGIN MIGHT AS WELL START UP HIS OWN CLOTHING
LABEL, TOO, IN ORDER TO CAPITALISE ON HIS FOLDER OF
IDEAS. THE DESIGNS ARE MOSTLY BASED ON THINGS THAT
HAVE HAPPENED TO HIM, OR THINGS HE HAS FOUND. THE
COLLECTION IS A DISPARATE ONE, ALBEIT WITH UNDERLYING
CONNECTIONS THAT ARE APPARENT ONLY TO GOGGIN. SEVERAL
OF THE DESIGNS HAPPENED TO BE METEOROLOGICALLY
RELATED – HENCE THE NAME.

"Since he views most modern fonts unfavourably, Goggin tends to create his own. He bemoans the ubiquitous use of some 'trendy' fonts, which quickly fall out of date."

implications of the term 'graphic authorship'. "In the fifties Charles and Ray Eames designed whatever they felt was right for the context of each project: from chairs to educational films. People like Paul Rand and Bruno Munari had no qualms about traversing disciplinary boundaries and I like that," says Goggin.

"The term 'graphic authorship' has sometimes been used to justify self-indulgent design which forges its own path aesthetically without any regard for the content," he continues. "But simultaneously I view it as an idea that may enable designers to contribute sensitively to a project's discourse or to have his or her own output through self-initiated works. I've always thought it logical that if a designer has a valid idea for a book, an exhibition or a T-shirt they should go ahead and produce it. But such endeavours are only successful if the idea and its application can stand up on their own within their disciplinary context."

"While in general I am against transparent, faceless design, you need to sometimes remind yourself of the fundamental role of a designer – visual communication," he says. "The extent to which the designer can appropriate a degree of authorship is invariably down to the client. Some clients approach me for a certain way of thinking

HELIX NEW FONT DEVELOPMENT, 1999
RANDOM SKETCHBOOK PAGE SHOWING STENCILLED LETTERING
AS WELL AS OTHER GRAPHIC EPHEMERA.

HELIX NEW ILLUSTRATOR DRAWINGS, 1999
SIMPLIFIED LINE DRAWINGS MADE OVER THE TOP OF VARIOUS
STENCIL SCANS WORK AS PRELIMINARY STUDIES FOR THE
HELIX NEW FONT.

or a particular aesthetic approach, and then it can be very interesting. But at the same time if I am working with an artist or photographer who has visually strong material, you have to respect their work. Often my contribution of a custom typeface or suggestion for binding or material will work together with the artist's vision; at other times the work itself is so strong there is no need for embellishment. The design manifests itself in the decision to not interfere. With commercial projects there is always the point that the client is paying for your work, so their needs must be fulfilled. While you have to be aware of this, I feel that it is also the designer's duty to point out ways in which the project can be better – to listen to the client's concerns, but also convince them with a well-thought-out argument if you have an alternative approach which you think could be more successful."

Helix New:

In January, the true colour of the Universe was declared as somewhere between pale turquoise and aquamarine, by Ivan Baldry and Karl Glazebrook at John Hopkin's University in Baltimore, Maryland. The cosmic colour was determined by combining light from over 200,000 galaxies within two billion light years of Earth.

Glazebrook now says the true colour this data gives is closer to beige. "I'm very embarrassed," he says, "I don't like being wrong." The mistake was caused by a bug in the software Glazebrook had used to convert the cosmic spectrum into the colour the human eye would see if it was exposed to it.

HELIX NEW, 1999

HELIX NEW IS A BASIC FONT DERIVED FROM THREE OR FOUR DIFFERENT HELIX STENCILS, WITH SOME CHARACTERS FROM AN UPPERCASE-ONLY STENCIL, AND SOME FROM A COUPLE OF LOWERCASE STENCILS. THE UPPER- AND LOWERCASE FONTS MORE OR LESS MATCH, BUT NOT QUITE. GOGGIN SAW THIS AS A FITTING REFERENCE TO THIS TYPE OF STENCIL, WHICH RARELY HAS BOTH UPPER- AND LOWERCASE ON THE SAME TEMPLATE. THE STENCIL 'GAPS' HAVE BEEN FILLED IN IN AN ATTEMPT TO CREATE A PROPER TEXT FONT THAT RETAINS THE IMPERFECTIONS OF HAND-DRAWN LETTERFORMS.

**Tim Hutchinson and Jason Edwards
of Bark, London**

When Bark's co-founder Tim Hutchinson was an assistant senior lecturer at Portsmouth University, he and other visiting, associate directors were asked to pitch for the job of designing the university's prospectus for the following year. The institution wanted its lecturers to practise what they preached in preparing the pitch and the resulting design. As an existing lecturer, Hutchinson was aware of Portsmouth's recruitment and publicity issues.

Hutchinson and his partner, Jason Edwards, developed a design that revealed the diversity and individuality of Portsmouth's courses, but also visually indicated a 'course path' showing how students can begin on an access programme and work their way through to a masters programme.

PORTSMOUTH UNIVERSITY PROSPECTUS, 2000
DIGITAL PHOTOGRAPHS, TAKEN DURING THE YEAR'S VISUAL
RESEARCH FOR THE PROJECT. THESE WERE DESIGNED TO
SHOW THE SOMETIMES GRIM REALITY OF THE UNIVERSITY'S
ENVIRONMENT AS A WHOLE. THESE IMAGES WERE THEN
ADJUSTED IN PHOTOSHOP AND USED WITHIN THE
PROSPECTUS LAYOUTS.

Bark

While Bark doesn't follow a mantra of creating its own graphic elements, it has found the process invaluable for commissions such as the Portsmouth University prospectus. Says Hutchinson: "Self-initiated elements are enormously effective but only if the idea requires it. The process doesn't suit all briefs; the brief governs the quantity of self-initiated work required. It doesn't necessarily make design better, but it does make it more rounded. The whole project was extended and enhanced by the treatment and the photography, and it separated the client from its competitors."

Continues Edwards: "For the Portsmouth University job we were dealing with people who have visual knowledge, so they understood the design and photography and the need for authenticity. The aim was to contextualise the idea and the self-initiation process for them to show how it works. In practical terms, we had to present our ideas to a panel of staff comprising the marketing department and head of school. They accepted the use of the course map metaphor illustrated by the visual essay at the front and the proposal to feature the facts at the back."

Taking the institution's mission statement as a starting point, Bark developed a 'visual essay' to show the courses on offer through genetic diagrams. "We sketched pictures of genetic diagrams from Open University text books and scanned them into the computer," explains Hutchinson. "Then we used Illustrator to network the sketches into the visual graphic element."

Bark's photography, which the duo feel made the work richer, created a narrative and fine-tuned "a visual essay into a photographic documentary". Edwards explains: "The photographs of the environment enabled us to tell a story. As this grew, it meant we could make the front end of the prospectus richer, initiating a photographic documentary – this was different to what we had

PORTSMOUTH UNIVERSITY PROSPECTUS, 2000
THESE DIGITAL PHOTOGRAPHS, UNUSED IN THE FINAL DESIGN, ARE NOT WASTED. BARK KEEPS A REFERENCE LIBRARY OF BACK PROJECTS THAT WERE NEVER REALISED. "IT HELPS US NOT TO FORGET OUR OWN IDEAS," SAYS HUTCHINSON.

"WE SHOW THEM TO SOME CLIENTS AS A SORT OF SUBVERSIVE PORTFOLIO. SOME CLIENTS BUY INTO THIS ENERGY AND RECOGNISE THE POTENTIAL OF OUR WORK IN THESE VISUALS. NOT ALL CLIENTS WANT TO VIEW ONLY COMMERCIAL WORK."

"Bark keeps a reference library of back projects that were never realised. 'It helps us not to forget our own ideas.'"

PORTSMOUTH UNIVERSITY PROSPECTUS, 2000
FINAL SPREADS FROM THE PROSPECTUS SHOWING THE

COMBINED USE OF SELF-INITIATED PHOTOGRAPHY AND
GRAPHICS IN THE FINISHED DESIGNS.

originally envisaged. The prospectus could have ended up as an entirely graphic piece of work."

Using a digital camera, the pair spent a year shooting images that avoided the look of clichéd prospectus pictures and showed the activity and grittiness of both the campus and Portsmouth itself. They felt these images reflected the "genetic connectivity" of the design and showed that the university was part of a wider environment.

Bark started experimenting with digital photography in 1999, and believe that the medium has challenged conventions in both collating and editing images. "Due to digital photography, people record images in a different way than before. You can shoot situations and environments – like corners of rooms – that previously you wouldn't have thought to shoot because of the process of lighting and setting up. It enables you to be more

photographically intimate with the subject and environment and record it like a documentary maker," explains Hutchinson. "Also, as so much of the designer's work is screen-based, the designer has a far better relationship with the camera when selecting which photograph to shoot or use because it is easier to visualise it on screen. It would have been impossible to realise these pictures with conventional photography due to budget, time and intimacy with the subject."

RESEARCH IN THE SCHOOL OF ART, DESIGN AND MEDIA

Research in the School of Art, Design and Media is characterised by an active engagement of theoretical and critical work with creative practice. Upwards of 40 staff and 20 research students are involved in group and individual projects that range from leading-edge experiment to applied research. The critically-informed use of new technologies in creative work and its implications for learning strategies are recurrent themes. Research in the School enjoys steadily increasing external esteem and is supported by a wide range of grant awarding, client and partner organisations.

The School has four research centres

01 › The Centre for New Media Research has an award-winning reputation for the development of innovative interactive media knowledge and learning resources, and basic research in the context-sensitive potential of new media.
Contact: paul.newland@port.ac.uk

02 › The Centre of Sound has rapidly developed a reputation for experimental inter-active installations which advance the understanding and enjoyment of sound. Current work includes a website dedicated to the exploration of sound and immersive environments for special needs.
Contact:chris.creed@port.ac.uk

03 › The Centre for Images in Practice is concerned with experimental work in illustration in a variety of contexts, and has initiated a major international web-based research collaboration.
Contact: maureen.o.neill@port.ac.uk

04 › The Centre for Creative Empowerment develops and evaluates creative pedagogy to unleash human potential. It has won national awards, including a major BT HE award, for linking schools and communities through creative work with multimedia.
Contact: valerie.swales@port.ac.uk

David Joyce and Robin Hegarty of Language, Dublin

Language is a multidisciplinary creative studio. As well as its commercial projects and work for community-based organisations or those campaigning for social change, it also uses self-initiated projects to explore areas of personal interest and to showcase work. Self-initiated work covers disciplines such as image-making, photography, copywriting, sculpture, print-making, book-making, comics and letterpress.

"Obviously we have to maintain a balance between all these areas of work. However, by initiating our own projects, we have an opportunity to explore new territory. This leads to an originality and richness in the commissioned work we do," says creative director David Joyce. "We can experiment, learn from our mistakes and really enjoy the process. For better or worse, it is the result of personal investment in the work. This means that the results can look more personal, because it consists of original elements."

For the last five years, Language has self-initiated a diary, containing work produced in-house and from selected contributors. "We can be our most difficult client!" says Joyce. "The diary is a gift to ourselves and our clients. It allows us to collaborate with a range of designers, writers and artists."

The starting point for the 2002 limited edition diary was the periodic table, with the table of elements forming the basis of the contributors' brief. This broad foundation led to experimentation with text and image that is as diverse as it is interesting. "It is always a pleasure to work with people outside of the studio. The mix of responses is stimulating and often surprising," says Joyce. For practicality, the diary has a grid and structure for framing the user's own content.

"The periodic table is a map of building blocks of all matter," Joyce explains. "It presents a mathematically structured basis for understanding the universe. Equally, a diary or a calendar is a mathematical structure by which we define time to each other and ourselves. Each person approached the brief in a unique way, resulting in a rich and diverse collection of work."

Most of the designs contributed were applied without further adjustment from Language. Those who chose to supply text or images allowed Language to develop these elements in the studio using various image-making techniques.

Says Joyce of the piece 'Docklands': "This piece developed from a body of ongoing work and considered the main gas works building site in Dublin. Historically, the site was used by boat builders, fishermen and then Bord Gáis (the Irish Gas Supply Board), but in recent times it has been developed for housing and retail purposes and has been responsible for the expulsion of gases such as radon into the surrounding area. My main interest in this project was the excavation of this site to prepare it for building. I was interested in the layers that were revealed and structures that were lost so that something else could be found."

Another self-initiated Language project is *FM* magazine. The Women's Education, Research and Resource Centre (WERRC) has a longstanding relationship with the design company and asked them to be involved with *FM* at an editorial level.

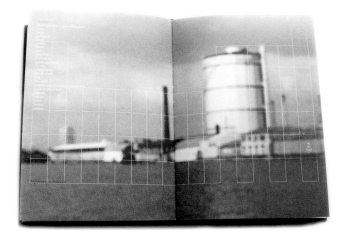

DIARY, 2002
LANGUAGE'S DAVID JOYCE TOOK THE IMAGE OF A DUBLIN GAS WORKS AS PART OF A PERSONAL PROJECT RESEARCHING HOW NOXIOUS GASES CONTAMINATE THE ENVIRONMENT FOLLOWING EXCAVATIONS. IN THE CASE OF THIS BUILDING, RADON WAS RELEASED. AS THE THEME FOR LANGUAGE'S 2002 DIARY WAS THE PERIODIC TABLE, JOYCE BLEW UP THE IMAGE AND LAID THE TABLE'S STRUCTURE OVER IT TO ACT AS A GRID SYSTEM. THE MAIN BODY OF THE TEXT WAS WRITTEN BY JOYCE AND WAS PRINTED IN ORANGE – THE COLOUR OF RADON.

The task allowed Language to explore innovative ways of presenting information and making visual essays, privileging image in the content of the magazine. The aim of the collaborative publication was to express a range of feminist views and to become an explorative vehicle for the designers and artists involved.

"We attempted to destabilise the natural authority ceded to the written word, by forming less linear, more fluid structures for text, and integrating non-textural features with the body of type," says filmmaker and contributor Neasa Hardiman. "This focused the reader's attention not only on the meanings constructed through the reading of the text itself, but also – and equally – on those generated by the visual construction of the magazine."

This is another example of a collaborative project between Language and contributors from outside the studio. Again, most of the contributed work was applied without adjustment, although some chose to work more collaboratively with Language. The client was very open to the visual ideas explored throughout the process; its only concern was readability.

Another longstanding association, this time with RTÉ, Ireland's national public service broadcaster, has led to an invitation to Language to create a five-minute promo to commemorate the centenary of Bloomsday in 2004. James Joyce's novel *Ulysses* is set in Dublin on June 16th, a day

"We discount design fees on some jobs, with the understanding that we have editorial control over the visual content."

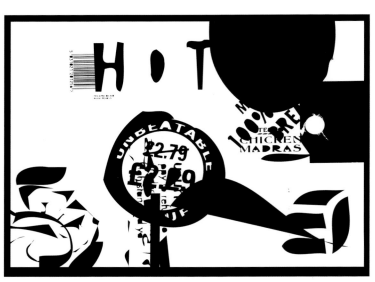

FM MAGAZINE, 1999
THIS ISSUE OF FEMINIST PUBLICATION *FM* MAGAZINE CONSIDERED ISSUES SURROUNDING FOOD CONSUMPTION. LANGUAGE RESPONDED TO AN ARTICLE ON INDIAN FARE BY CREATING A TYPOGRAPHIC ILLUSTRATION FROM SOME BRANDED FOOD PACKAGING. LANGUAGE DECONSTRUCTED

THE TYPE VIA A COMBINATION OF SCANNING, STREAMLINING AND CUTTING AND PASTING. THE WHOLE MAGAZINE WAS TURNED AROUND BY LANGUAGE IN A WEEK.

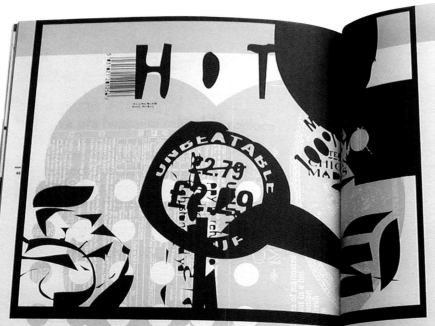

"Can you make a curry?

What's a curry anyway?

by Shalini Sinha

"Can you make a curry?"

The words shocked me. I was sitting in my living room with a group of friends, none of whom were Indian, when Indian food suddenly became the focus of discussion.

Can I what? Of course I can make a curry! I am an Indian woman and an Indian woman makes curries.

But I had never heard of a curry. It was not a word we (my Indian family) had used to describe food. Suddenly, all my insecurities about growing up as an Indian woman outside of India were running out of control. Of course I can make a curry! All Indian women make curries. But, what's a curry, anyway?

Until then, I had lived all my life in a traditional Indian home. It was my parents' home, and they were really Indian. My parents had been born and brought up on the subcontinent, and as a result, there was no question of who they were and where they came from. I, on the other hand, was born in Canada, and nothing about who I was seemed clear. Growing up in the diaspora, my identity was always in question. Was I Indian enough? This question haunted me. While I could speak Hindi and often wore Indian clothes, somehow I got the impression that I had to be able to cook Indian food to be really Indian.

As a result, hearing this word, "curry", made me panic. Not only did my rights to "Indianhood" seem in question, but I had also felt like an outsider in Canada. Now, the strangest thing was happening around me. It seemed everyone I knew was talking about Indian food. For the first time I could remember, my fixation was a source of excitement rather than ridicule. What seemed normal, however, was the fact that I couldn't participate. Central to the chatter born before me were things like "vindalloo", "rogan ghosh", "korma". I had never heard of these things.

It's not as though I was used to hearing people go on about the marvels of Indian cuisine. When I was growing up, mostly I was ridiculed for the foods I ate. In school, I was met with sharp disdain. For lunch one day, I had brought an average meal: leftover rice, dahl (lentils) and vegetables, maybe with some yoghurt and a drop of lemon, all mixed up into one great and glorious mush! Such a common sight was not worthy of attention. I had had this often, when I went home for lunch in primary school. But now I was in secondary school with my Tupperware in hand, and as I popped the airtight seal and unleashed the beautiful aroma, I suddenly heard sirens go off: "What's that smell?" "Ew! It's like baby puke!" I was humiliated. Growing up as the only Indian child in a sea of White people, I had learned, so I thought, the lessons of not drawing attention to myself. How could I have made such a big mistake?! I soon stopped bringing a lunch at all.

This memory was now sitting juxtaposed to what was happening in my living room: Indian food revered. Excitement for my current situation did not last long as my exclusion from the festivities became apparent. All my years I had paid careful attention to collecting pieces of evidence which would prove that I was in fact Indian. As I quickly scanned this store, however, there seemed to be no clues to educate me on what a "curry" was. My diasporic scars were becoming visible. I was an Indian woman, yet this was proving that I knew nothing about Indian food! The devil's advocate that, for years, had argued that I had no valid claim to Indian history was now smiling in my head. When this happens, there is only one option: shun the celebrations altogether. "There's no such thing as a curry! I know, I'm Indian," I thought to myself.

It was my silent, rebellious declaration to the world. I would have no more of this nonsense — this trial of my identity. I would have no more of these White strangers proving to me that they knew more about India than I did. But my defiance was clear, and as I have come to learn later, defiance is no step closer to liberation. This struggle with food was, for me, not merely academic. It was not simply that I felt I could not claim being Indian because I did not know all that needed to be known about Indian food. It is more complicated than that. I was raised Hindu, and for Hindus, food is very important. It defines us. It is a marker of our culture and a

"I feel that the issue of graphic designer as artist has been knocking around for a long time," Joyce says. "It seems odd that people feel the need to quantify what this means. If a cabinetmaker creates a sculpture, what do you call it? A rush to the head?"

that has become known as Bloomsday, and Language has been asked to create a vehicle to celebrate the exciting and extravagant universe within the novel.

Language investigated both the story and the author, and has explored ideas using multimedia, broadcast programming and the innovative Ulysses Centre, located in Dublin's new digital media district. This centre will be both an interactive museum and a centre for creativity in the use of digital media.

A script was written in-house and Language produced a five-minute film that would illustrate the concept. Copywriter Henri McKervey says: "We managed to create a contemporary world view of an aspect of the novel by focusing on its layered nature and the richness of its content. It was an opportunity to create something from the novel by locating it in a modern context in addition to acknowledging its original world view."

Images were collated from various sources, both found and made. Throughout the process, the self-initiated elements were presented to the client. They gave positive and useful feedback, allowing Language to explore areas not previously considered.

Language either funds or discounts the work that it considers to be exercises in graphic authorship. "We discount design fees on some jobs, with the understanding that we have editorial control over the visual content," explains designer Robin Hegarty.

"If graphic design is about thinking visually through ways of assisting content then, for me, graphic authorship is the making of the content," he adds. "The inclusion of original elements within a design is not authorship, it is the job and what graphic designers do. Personal investment in your own work is not self-indulgent if it is clear about what it communicates to the viewer. It is, however, important to be motivated in the pursuit of personal and investigative projects, to commission oneself in order to give breath to a particular idea or technique. It is also important to publish and distribute this work, if only to get it out of the studio."

Language believes the self-initiated content is the trigger for what is produced; the work could be called 'art', but only if the client is the designer and the brief is set by the designer. "I feel that the issue of graphic designer as artist has been knocking around for a long time," Joyce says. "It seems odd that people feel the need to quantify what this means. If a cabinetmaker creates a sculpture, what do you call it? A rush to the head?"

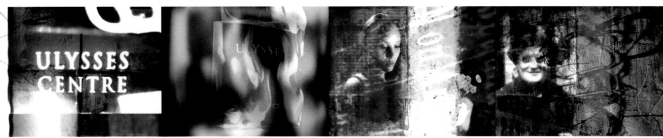

ULYSSES CENTENNIAL PROMO, 2002
DUE TO BE SHOWN IN 2004, THE ULYSSES PROJECT IS SHOWN HERE FROM INITIAL SKETCHES TO ILLUSTRATIONS TO A SERIES OF SCREEN GRABS FROM THE RESULTING PROMO. THE IMAGES WERE CREATED FROM DRAWINGS AND PHOTOGRAPHY AND WERE MANIPULATED IN PHOTOSHOP TO CREATE A MONTAGE. THESE MONTAGES WERE PUT THROUGH FLAME – THE STATE-OF-THE-ART POST-PRODUCTION SOFTWARE PACKAGE, FOR THEM TO FUNCTION AS BACKGROUND ACCOMPANIMENT TO THE LIVE-ACTION MOVING IMAGES.

Sara Fanelli, London and Florence

Born and bred in Florence, Italy, Sara Fanelli produces work based on an integrated and totally self-initiated approach. "I see myself as being a designer as well as an illustrator. I'm interested in composition, painting, typography and the whole production process. As far as I am concerned, I work in my own way, and most of my commissions come from clients who see my work and are inspired to employ me."

Fanelli's clients are diverse, and include publishing houses such as Jonathan Cape and Faber & Faber, as well as the BBC, NatWest bank and furniture designer Ron Arad.

As she happily manages all of the processes involved in creating images and text, Fanelli's work is completely self-initiated, although she occasionally collaborates with other designers to explore new areas. She is adamantly opposed to the argument that designers who self-initiate offer their clients an easier alternative. "Designers and illustrators who have developed their own distinctive voice are not merely regurgitating or adapting their style for each commission in some mechanical way to be seen as a soft option," she says. "Whether my work is for myself or commissioned, I have no interest in repeating my solutions."

Fanelli's interest in illustration lies in the opportunity it offers for a personal interpretation of a text. She adds: "I enjoy using collage as a medium. It allows me to work with different layers of meaning."

A recent commission for Fanelli was the design of an invitation to the opening of the Alessi showroom in London in 2001. Armed with an open brief but an exceptionally tight three-week deadline, Fanelli had to devise an invitation that reflected the 'six floors of creativity' housed in the showroom.

Fanelli opted for a concertina format that folded into six sections to represent the floors of the shop. On one side, the information is presented in Fanelli's own handwriting in upper- and lowercase, while the other side shows a series of collages spelling out 'Alessi'. These were created out of old notepaper, painting and type.

For the Milan Furniture Fair in 2002, Fanelli created another invitation for the show of furniture designer Ron Arad.

ALESSI INVITATION, 2001
FOR FANELLI, THE ALESSI INVITATION WAS VERY MUCH AN AUTHORSHIP PROJECT. "A CLIENT SUCH AS THIS EXPECTS SOMETHING COMPLETELY ORIGINAL BECAUSE OF THEIR OWN INTEREST AND UNDERSTANDING OF DESIGN. THIS IS AN EXAMPLE OF A CLIENT WHO COMMISSIONED ME EXPECTING ME TO REMAIN TRUE TO MY OWN VISUAL WORLD."

Sara Fanelli

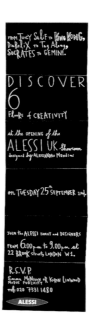

Again faced with an open brief and very tight deadline, Fanelli designed the piece from a sheet of A4 paper folded in half lengthways. The front side, on which was printed one of Fanelli's collages, was die-cut into a series of almost one hundred very thin strips.

The back of the invitation reveals several insect characters on a background of curtain-like wallpaper around an image of Milan that Fanelli had found on an old postcard. The text is a mixture of Fanelli's handwriting and the font Clarendon. "The shapes of my insects were influenced by the shapes of Ron's furniture in the show," she explains, "while the image on the back of the invitation is an ironic comment on the fair in Milan, with the insects suggesting trendy designer types."

Fanelli has had several children's books published for which she has authored both the story and the design. The book *Dear Diary* began as a personal project until it caught the attention of a publisher. "I find the book format most stimulating and I am continually trying to explore interesting ways of conveying text and imagery.

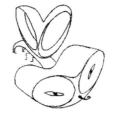
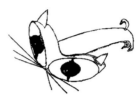

RON ARAD INVITATION, 2002
THIS FRINGE EFFECT WAS INSPIRED BY ONE OF THE PIECES IN ARAD'S SHOW: A CURTAIN MADE OF FIBRE OPTICS ON WHICH IMAGES COULD BE PROJECTED.

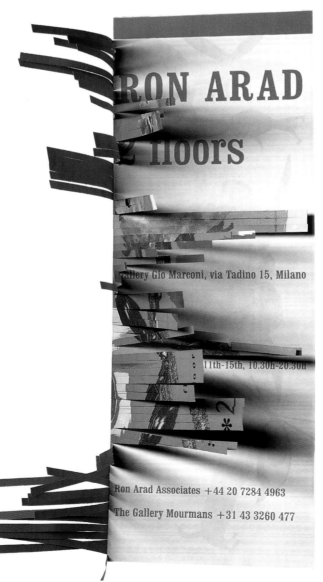
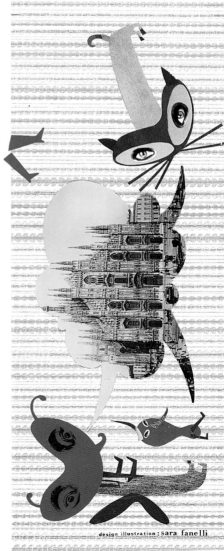

RON ARAD
& floors

Gallery Gio Marconi, via Tadino 15, Milano

11th-15th, 10.30h-20.30h

Ron Arad Associates +44 20 7284 4963

The Gallery Mourmans +31 43 3260 477

design illustration: sara fanelli

As the author of these books, it is really important to me that I am in control of every aspect of their production, even choosing the paper the book is printed on, or correcting colour proofs."

But does she see the notion of authorship as self-indulgent? "It is vital that the author has a definite message which is not superficial. It's also essential that the author doesn't confuse individuality of style with self-promotion."

Some of Fanelli's main influences are literature and theatre, graphic and commercial art from the first half of the twentieth century, music and travelling. These are all evident in her collages. "I collect items for use in my collages from all these areas of interest and I like creating a sub-narrative with dialogue occurring between these different elements." says Fanelli. "I also occasionally enjoy collaborative work. For instance I worked with Chris Bigg of V23 on a CD and on my latest book *First Flight*."

First Flight was published by Jonathan Cape in 2002 and is the story of a small butterfly's struggle to learn how to fly. A charming tale, it ends with the butterfly instinctively flying towards its mother. For the endpapers of the book, Fanelli combines drawings of butterflies created by a selection of her family and friends ranging from a child of two to a 93-year-old. On the bottom left-hand corner of each page, Fanelli created a series of butterfly illustrations that build into a flipbook revealing the butterfly flying. From initial idea to publication, the project took Fanelli two years.

In *Dear Diary*, seven different characters tell their version of events on one particular day, in seven different diary entries, so the whole book

FIRST FLIGHT SKETCHES, COVER AND SPREADS FROM THE BOOK, 2002
THROUGHOUT THERE IS A RICH SELECTION OF FANELLI'S COLLAGE, PAINTING AND ETCHING.

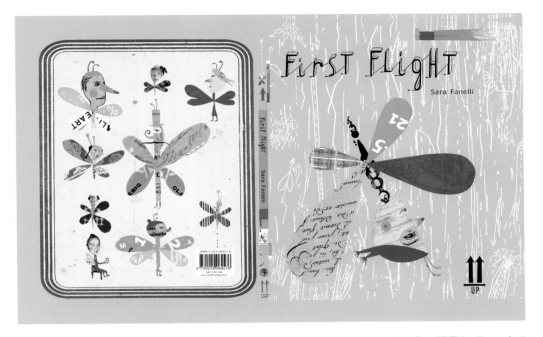

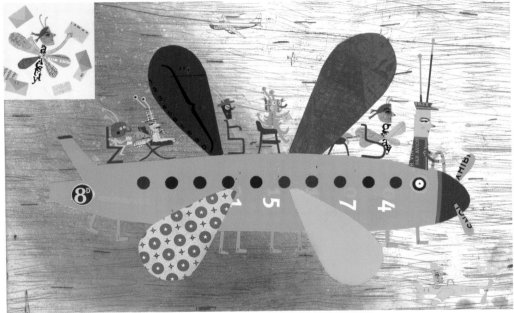

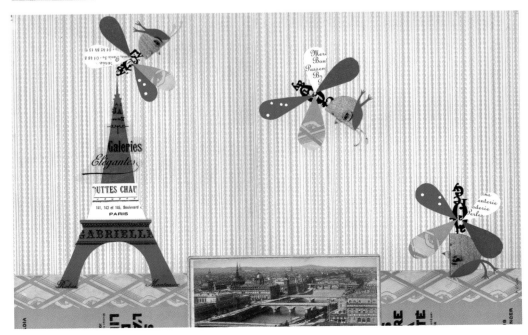

reflects seven different points of view. "I proposed the idea to Walker Books," explains Fanelli. "They gave me a contract and I developed the book. It took me about 18 months. When I present a new idea for a book to publishers, I produce pencil roughs to show the composition of every page, and perhaps a couple of double-page spreads in colour. But by now the people who commission me are familiar with my work – so they trust my vision of the book without always seeing every detail in advance."

"In *Dear Diary* I used a different handwriting style for each character," she explains. "The spider, for example, has scratchy, insect-like writing, while the girl has good calligraphy which she is learning at school. The dog has a rough and scruffy style."

"I think my work is instantly recognisable as mine," she adds. "This happens unconsciously and it is definitely not something I aim for. I certainly don't have a formula which I mechanically reproduce and I feel each of my books is quite different."

"Designers and illustrators who have developed their own distinctive voice are not merely regurgitating or adapting their style for each commission in some mechanical way ... I certainly don't have a formula."

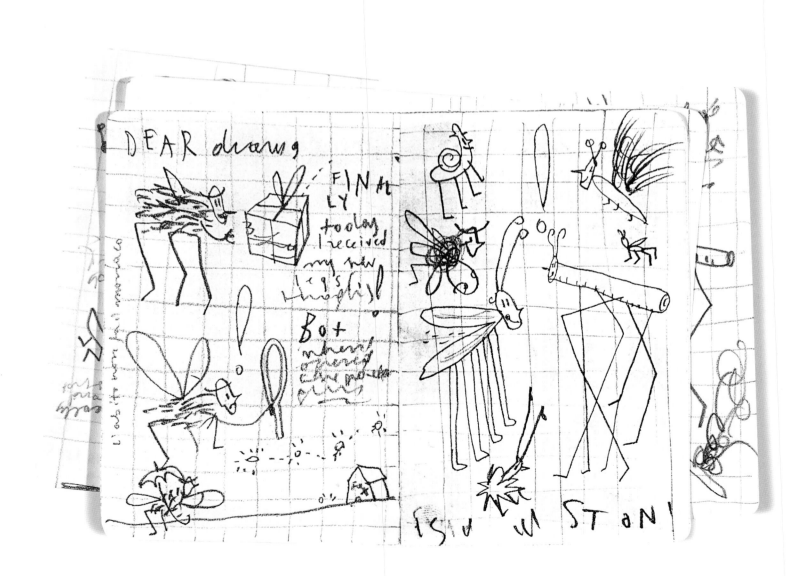

When it comes to clients, in the majority of cases Fanelli is fortunate enough to have found that most of them are sympathetic towards her approach. "It's nice to be commissioned by design-literate clients who like what I do and have respect for me as an artist, but also have the confidence that I will fulfil their brief and create something new especially for them."

DEAR DIARY SKETCHES, COVER AND SPREADS, 2001
DEAR DIARY WAS PUBLISHED BY WALKER BOOKS AND WAS INSPIRED BY FANELLI'S EPHEMERA COLLECTION, WHICH FEATURES OLD LABELS, PAPER, POSTCARDS AND STATIONERY.

"I WAS ATTRACTED BY THE IDEA OF CREATING A NARRATIVE USING THESE ELEMENTS THAT I HAD BEEN COLLECTING FOR A LONG TIME," FANELLI SAYS.

Golan Levin of Design Machine, New York

As most software doesn't allow him to push design as much as he would like, Golan Levin writes his own, creating digital tools to produce a unique look for each job that also cannot be realised by other designers.

"I would describe myself as a designer who uses the techniques of software engineering," he explains. "While the design is unique, it doesn't necessarily mean that the work is better than design produced by more traditional means. Nevertheless, the self-initiation of my own software does give me more control over the design process."

New York-based Levin studied fine art in the mid-nineties before working in a research lab at MIT. He then went on to study interactive art and design at graduate school before joining Design Machine.

"I am influenced by the world of algorithms," he says, "and John Maeda, with whom I studied at MIT."

In 2000, *Zoo* magazine invited Levin to produce a project for publication with no brief. He responded by taking pictures of his family and friends to develop into a portrait series using a sequence of photographic treatments. "I programmed my Photoshop filter with precision postscript graphics and wrote the system in Java," he says. "*Zoo* invited me to contribute to an issue after seeing my work on a website somewhere. I had a completely free rein. I produced an image of precisely placed lines using the same co-ordinates as found in a mass of bubbles. It certainly couldn't have been achieved by human hand."

He adds: "Each project generally takes me a few days. It takes a day to get it working and two days fixing it. I spend 80 per cent of my time tweaking a job."

Levin doesn't like to repeat his applications, as he is more interested in developing new techniques. He continues: "I do a lot of personal

"I have a burning desire to see something new, but as a designer my role is preconditioned because of the brief. Design is different from art since with art it's your solution so you might as well take some credit. Of course I've got deep inner angst, but it has no place when working on a BP logo."

Golan Levin

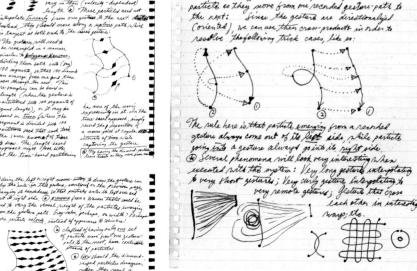

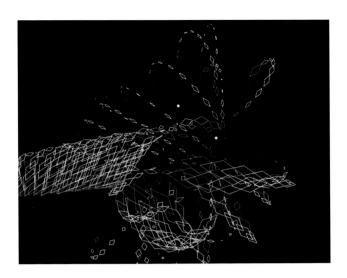

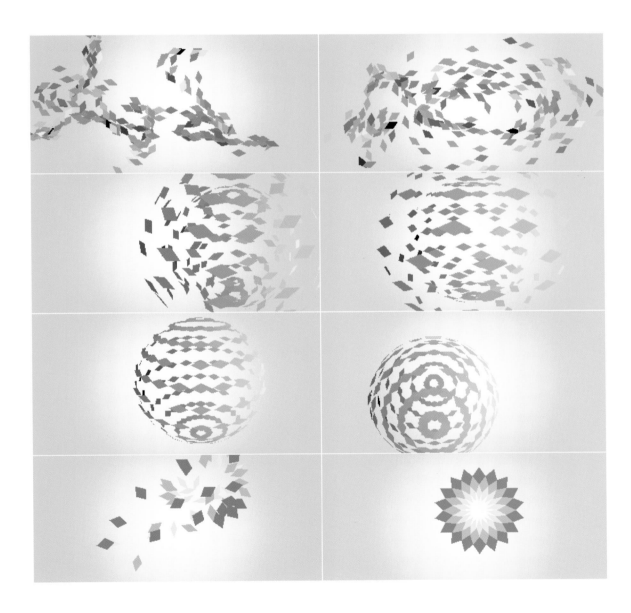

SKETCHES FOR *MESHY* **(LEFT),** *MESHY* **AND SUBSEQUENT BP LOGOTYPE (ABOVE), 2001**
THE BP ASSIGNMENT WAS AWARDED TO LEVIN BECAUSE THE ART DIRECTOR SAW HIS BLACK AND WHITE SELF-INITIATED ONLINE PIECE *MESHY*, WHICH IS REALLY WORK-IN-PROGRESS FOR THE BP AD.

THE COLOURED SERIES OF SCREENSHOTS OF THE INTERACTIVE LOGOTYPE LEVIN DEVELOPED FOR BP USE THE ELEMENTS OF BP'S 'GREEN SUN' BRANDING CAMPAIGN. THE PETALS OF THE FLOWER ALTERNATELY MORPH INTO A TRAIL FOLLOWING THE USER'S CURSOR, BEFORE COMING TOGETHER TO FORM THE SHAPE OF 3D PLANET. (FOR A LOOK AT THE APPLET PLEASE SEE: WWW.FLONG.COM/BP/)

projects but they are very costly to produce. I do regard myself as an artist, as I am questioning and I have a burning desire to see something new, but as a designer my role is preconditioned because of the brief. Design is different from art since with art it's your solution so you might as well take some credit. Of course I've got deep inner angst, but it has no place when working on a BP logo."

Levin won the BP job through London-based design and internet company Studio AKA. He had posted a piece of his work called *Meshy* online that used diamonds, as did the BP logo, so consequently the art director at Studio AKA "reckoned I knew something about making interactive rhombi". The resulting sequence revealed a series of animated diamonds, and Studio AKA, who had created a commercial for BP's 'Green Sun' campaign, wanted Levin to produce the interactive version for a pitch.

The television commercial showed a sequence of moving green 'leaves' which then formed the BP logo. Studio AKA's brief to Levin was to produce an interactive logotype of leaves/petals moving together and to ensure that they had the right behaviour and interacted together correctly in a linear narrative space. The movement of the leaves functioned in three different modes, as they followed each other around, creating 3D shapes before forming the BP logo.

"I used 3D projection techniques that allowed for the assimilation and bounciness, and in order to create this I wrote new software in Java," says Levin. "The leaves/petals alternatively morph into a trail following the user's cursor, and traffic elements on a 3D planet."

Levin was also commissioned by German exhibition design company art+com. "The company's director was feeling a bit frisky and redesigned the company's logo for the first time in ten years, and the new logo reinforced the positive and the negative space in the design. He saw my work when he was a jury member on a jury that awarded me a prize."

Levin's interactive logotype solution was to use a 3D application in a simulated 3D world showing the A and C turning over and over. When the two

ZOO MAGAZINE: SEGMENTATION AND SYMPTOM, 2001
A VORONOI DIAGRAM, WHICH IS COMMON TO PROPOSITIONS SUCH AS BUBBLES, INSPIRED THESE TREATMENTS, WHICH LEVIN APPLIED TO A SERIES OF PHOTOGRAPHS OF FAMILY AND FRIENDS.

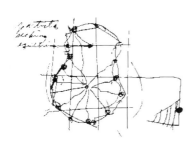

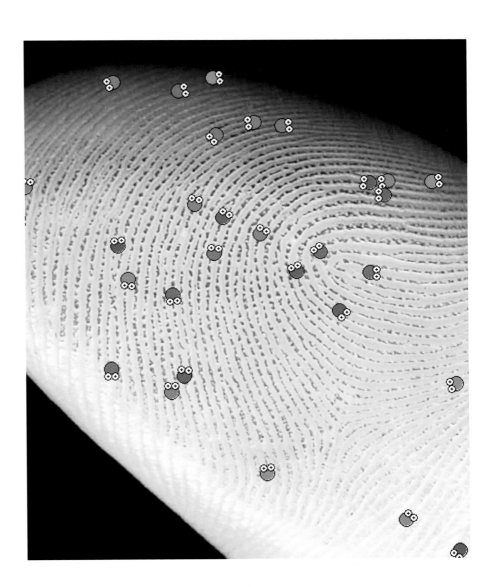

FINGERBAHN, 1998

LEVIN'S EXTENSIVE PERSONAL WORK INCLUDES THE FINGERBAHN. "THIS IS A VISUALISATION OF ALL THE LITTLE BUGGIES WHO SPEND THEIR LIVES ON OUR HIDES," SAYS LEVIN."THE USER CAN GIVE EACH OF THE BUGGIES A UNIQUE STARTING POSITION; IMMEDIATELY THEY'LL BEGIN TO MOVE ALONG THE GROOVES OF MY FINGERPRINTS. TO MAKE THE FINGERBAHN I COMPUTED A FLOW FIELD FROM EACH FINGERPRINT; THE BUGGIES THEN COMMUTE BACK AND FORTH ALONG THIS."

letters connect in the right position, they form a plus sign in the centre of the space. "Consequently the letters form their own negative space," he adds. "This happens under user control when he or she clicks on the letters. The project applies 3D transformations to a reversal of positive and negative spaces in order to convey the idea of a company at the intersection of design, communications and commerce."

Interestingly, Levin avoids explaining the way he works to clients by concentrating on those who are design literate. "I hope you don't mind if I sound a bit élitist," he says. "But I get enough work from clients who have design knowledge, and I prefer not to have to explain what I do to non-design literate ones. I'm not smug or self-satisfied with my work and I barely make a living doing what I do. It's just that this is the only way that I know how to work, and it's the only way that I find interesting and worthwhile. There is enough commercial work filling up the void. If you want to be an artist you can play God in your own little world, but I do feel like an author."

ART+COM, 2001
THESE ARE SCREENSHOTS OF AN INTERACTIVE LOGOTYPE DEVELOPED FOR ART+COM IN BERLIN. THE PROJECT APPLIES 3D TRANSFORMS TO A REVERSAL OF POSITIVE AND NEGATIVE SPACES IN ORDER TO CONVEY THE IDEA OF A COMPANY AT THE INTERSECTION OF DESIGN, COMMUNICATIONS AND COMMERCE. THE LOGOTYPE CAN BE VIEWED ON THE COMPANY'S HOME PAGE AT WWW.ARTCOM.DE

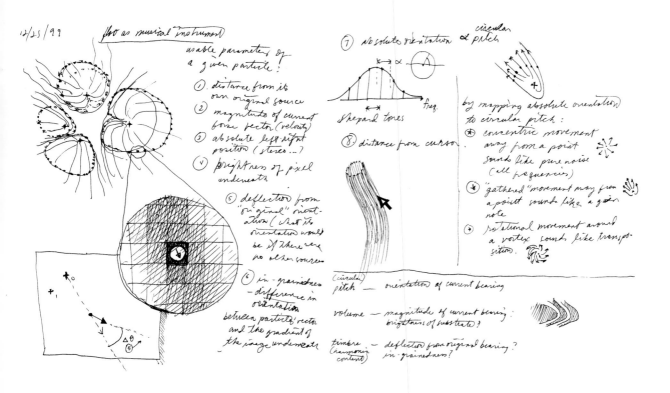

FLOO: SCREENGRABS AND SKETCHES, 1999–2001
THIS IS AN INTERACTIVE AUDIOVISUAL ENVIRONMENT CONSTRUCTED AROUND A NAVIER-STOKES SIMULATION OF FLUID FLOW, AND IS ANOTHER EXAMPLE OF LEVIN'S PERSONAL WORK. USERS CREATE SYNTHETIC SOUND AND IMAGE BY DEPOSITING A SERIES OF FLUID SOURCES ACROSS THE TERRAIN OF THE SCREEN, AND THEN STEERING A LARGE QUANTITY OF PARTICLES THROUGH THE FLOW FIELD ESTABLISHED BY THESE SINGULARITIES. AN IMAGE IS GRADUALLY BUILT UP FROM THE LUMINESCENT TRAILS LEFT BY THE PARTICLES. THE SHAPES OF THESE TRAILS ARE ENTIRELY A RESULT OF THE FORCES ORIGINATING FROM THE USER'S CURSOR AND THE FLUID SINGULARITIES. AS THE PARTICLES TREAD AGAIN AND AGAIN

OVER A GIVEN LOCATION, THAT SPOT BECOMES BRIGHTER AND BRIGHTER. FLOO IS SONIFIED BY A CUSTOM SOFTWARE GRANULAR SYNTHESISER WHOSE SOUND-PARTICLES MOVE IN A CIRCULAR PITCH SPACE. (A SMALL VERSION OF FLOO IS AVAILABLE ONLINE AT:
HTTP://ACG.MEDIA.MIT.EDU/PEOPLE/GOLAN/FLOO/)

THE SKETCHES ILLUSTRATE THE INNER WORKINGS OF THE FLOO SYSTEM. THE UPPER DRAWING ILLUSTRATES THE DIFFERENTIAL EQUATIONS THAT GOVERN THE SYSTEM'S SIMULATION OF FLUID FLOW; THE LOWER DRAWING IS AN EXPLICATION OF HOW THE SYSTEM WAS LATER USED TO GENERATE SOUND.

$$f(y, \dot{y}) \longrightarrow f - \dot{y}\,\frac{df}{d\dot{y}} = C$$

$$f(\dot{y}, x) \longrightarrow \frac{df}{d\dot{y}} = C$$

$$f(x, y) \rightarrow \frac{df}{dy} = 0, \quad f = C$$

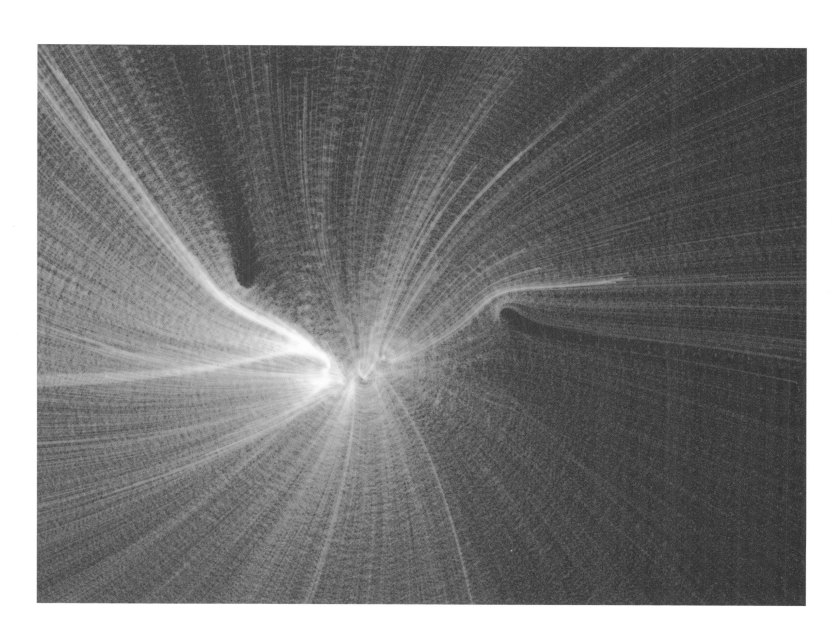

Todd St John of HunterGatherer, New York

New York-based design company HunterGatherer has a refreshing attitude to design. "Our work is very much about popular culture – we started making things that interested us and our friends," says founder Todd St John. "It is important that graphic designers can speak to a larger audience beyond that of other designers."

"I think I fell into design by default," St John continues. "My original interests lay more in music and film, but I also drew a lot as a kid. When I got to school and discovered graphic design, it wasn't necessarily exactly what I wanted to do, but it seemed closer than any other discipline I'd come across. It's inclusive of a lot of different mediums and possibilities, and that was a large part of the attraction to it. I heard someone use the term commercial art recently, and I think maybe that is more fitting. Typically what we do and are interested in has a commercial element – it's for sale and produced in quantity. Sometimes it's for a client and sometimes it's not."

HunterGatherer was founded in 2000 in New York. The name is derived from themes of primitiveness, shoppers and collectors. "Our design process is about bringing things in, putting our own ideas into stuff and putting it out again," says St John, "so hunting and gathering". In

addition to designing and producing a product line, the studio collaborates with a limited number of companies on a wide range of outside projects including design, illustration, animation and video work. Gary Benzel, based in San Diego and co-designer of the HunterGatherer product line along with St John, is a frequent collaborator. The two are also the founders and designers of the clothing label Green Lady.

"We founded Green Lady in 1994, originally to make things for friends. We sold to more and more stores as time went on, eventually opening a shop with the same name. This has allowed us to have an ongoing relationship with the people who buy our products, and has created a body of work and ideas that has developed over a number of years, as compared to individual design projects that tend to have shorter life spans."

According to St John, the company's desire to make its own work has allowed it to participate in all parts of the business, from clothing and posters to retail design. "The self-initiation of our own work has also led to invitations to do exhibitions," he says. "Which has been an aspect that we didn't really anticipate."

"I don't think that this tendency to self-initiate makes things better or worse," he continues. "Some of our favourite and most successful

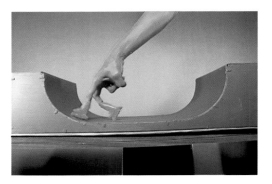

HunterGatherer

MTV SPORTS AND MUSIC FESTIVAL 5 (SMF5) IDENT, 1999
THE INITIAL BRIEF TO HUNTERGATHERER FOR THIS COMMISSION
WAS TO WORK ON THE LOGO AS A 3D CONSTRUCTION. THIS
PROCESS ENCOURAGED ST. JOHN TO INTERACT WITH
FINGERBOARDS, WHICH WERE BEGINNING TO COME INTO

FASHION AGAIN AT THE TIME. THE SETS WERE BUILT AND
SHOT, AND THEN MODIFIED GRAPHICALLY ON THE COMPUTER.

"I think that whether it's commissioned or not, there is an aspect of self-indulgence to the work that most designers create, if only in the sensibility they bring to the project. We try to do things that will be of interest to others, that act as a connecting point."

projects are collaborations with clients, while others are self-initiated. I think that whether it's commissioned or not, there is an aspect of self-indulgence to the work that most designers create, if only in the sensibility they bring to the project. We try to do things that will be of interest to others, that act as a connecting point. I think graphic design, more than fine art, is a kind of shared language – a cultural shorthand."

Prior to forming HunterGatherer, St John worked at MTV as an art director to further his skills and learn how to film and create animation, and he still works for MTV on a project-by-project basis. One such commission was a series of idents for a sports and music festival.

The concept behind HunterGatherer's MTV Sports and Music Festival 5 (SMF5) ident was borrowed from a video St John had made with some friends in high school. "In that way we were probably reverting back to a mental place that might not have naturally occurred now," he says. "We made a test version – an actual piece, so we were presenting more than just boards. I'd also worked with some of the people and producers involved, so there's been a level of trust built up

over a few years. The actual shooting and constructing of 'sets' was done in about two days, and there were about three friends that we involved in doing the voices, and even making the sets."

Says St John: "When client-driven projects aren't turning out well, it's easy to blame the client. But when you start doing self-generated work and it doesn't turn out well, you realise there's only yourself to blame."

HunterGatherer considers what the client has to spend when it charges for self-initiated elements. "We try to charge what is fair, and what a client and project warrants," explains St John. "What we do is very populist, democratic and quick-head-turn sort of stuff; clothing graphics have to operate on a quick-read level first, and then there may be secondary readings upon further examination. But I wouldn't extend this interpretation to all graphic design."

Consequently, the designers at HunterGatherer have no aspirations to be considered artists. "In fine art there are certain ways of working ... developing a distinct body of work that has a direction and progression is emphasised much

more than in graphic design," says St John. "I don't consider myself a fine artist. Although, over the last 40 years, there has been more and more blurring between graphic design and fine art, with one area borrowing the techniques and language of the other. I sometimes think that graphic design doesn't really exist anymore ... that we may be holding onto an idea of what the industry is that is long outdated. I'm not saying that graphic designers are all becoming something closer to artists; I'm just saying that the term can now mean so many different things."

SKETCHES FOR MTV SPORTS AND MUSIC FESTIVAL 5 (SMF5) IDENT, 2001
THIS IS A RECYCLED IDEA FROM A 'SURF VIDEO' ST JOHN ORIGINALLY MADE IN HIGH SCHOOL THAT INVOLVED PAPER CUT-OUTS. THE SETS WERE MADE OUT OF CONSTRUCTION PAPER, AND ALL THE SOUND EFFECTS AND ACTION WERE SHOT AS A STRAIGHT TAKE.

skatevert smfive MTV

STILL FROM MTV SPORTS AND MUSIC FESTIVAL 5 (SMF5)
IDENT, 2001
THE HANDMADE QUALITY OF THIS IDENT – BORN OF THE
SELF-INITIATED APPROACH OF HUNTERGATHERER, INFERS A
RAW, LIVE QUALITY TO THE PROGRAMMES THAT THE IDENT
IS ADVERTISING.

"I sometimes think that graphic design doesn't really exist anymore ... that we may be holding onto an idea of what the industry is that is long outdated. I'm not saying that graphic designers are all becoming something closer to artists; I'm just saying that the term can now mean so many different things."

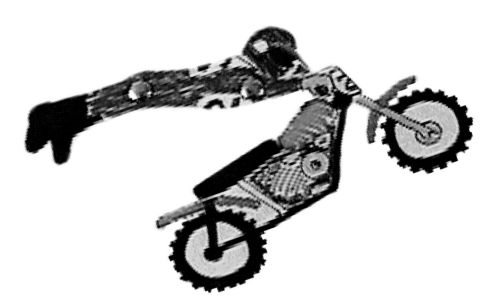

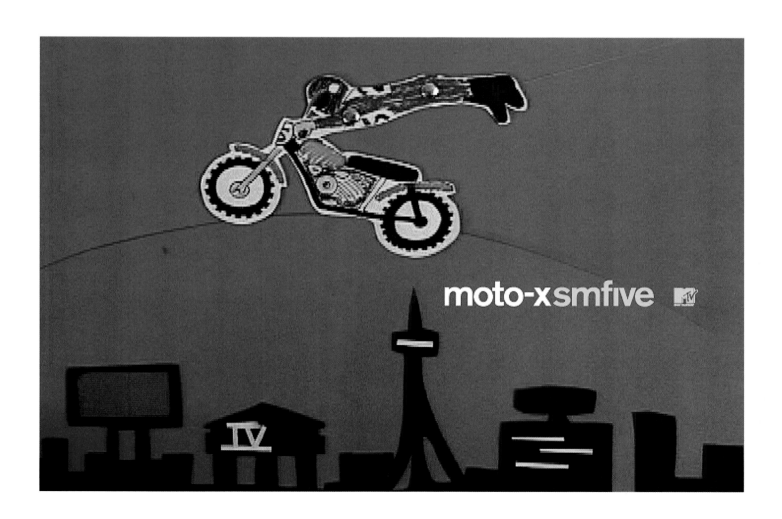

Niall Sweeney of Pony, Ireland

The photographic image provides the creative thrust of the work of Irish-born designer Niall Sweeney.

"The process of photography itself has as much to do with the way I work as the actual work being produced – the projected and received image. Taking photographs is akin to the way we all discreetly manage our own perceptions of the world, those blinkered views we all have, or should I say 'framed views' to be polite? Taking photos is a way of possessing, as well as representing. I possess and then I re-present – what happens in between is the work, I suppose – and I am never precious with my own possessions. Nothing I own is 100 percent right. Something is always 'on-the-wonk'. Those 90-degree corners always seem to get knocked to about 87 degrees by the time I get the bloody thing home. There is always a bit of dirt in there. I like dirt. Dirt is the unknown."

In an attempt to describe the way he works, Sweeney describes a typical photographic adventure: "You go running around all these amazing cities all over the world and you have these various projects in your head and everything you look at resonates in some way with them. You run in and out of spaces and non-spaces – taking all these images – and you get back and the contact sheet is like the storyboard to a film in your head. You're looking along the film-strip and it's all lovely shots of chairs and doorways and buildings and dirt that you saw that day. Then it jumps to five progressively blurry shots of a drag-queen in a club taken far too close for make-up and then it jumps to two days later because you left your camera in someone's hotel room and it took that long to remember where the hell that was and *who* the

hell he was. But now you own all those moments on that contact. And now you have a story to tell. And that's really the way it works. I'm always looking for a kind of resonance between deliberate and random events – the tangible event that occurs when you bring two things close enough together. It happens in language and music. It happens in memories.

I see my work as a way of making mnemonics for memories you haven't had yet. That's why I take photographs. It's like map-making for undiscovered territories."

He continues: "Sometimes I try not to explain the way I work to a client, and, as you can imagine it might get a bit confusing for them; I can veer off on storytelling tangents if I start talking about it. It all depends on the context. Context is king. And the process of making is as much a part of that context as the final outcome. Clients like D1 Recordings have been with me for many years, so working this way with them is just the way it seems to work. So those shaky images of buildings for DEAF2002 [Dublin Electronic Arts Festival], which D1 is producing, are just further extensions of the stories I have been telling with them over the years. With new clients, the process at first is not important, it's the communication between myself and themselves that counts – the process just falls out of that conversation, and takes whatever form is appropriate. Only then can we start exchanging stories."

Sweeney's studio boasts a hefty photographic library. "As I take more and more images and they progressively colonise the surfaces of my studio, patterns seem to be emerging – geometrical and conceptual – and I think that I really only take two kinds of photo: the manufactured environment and men in dresses. But then, really, cities are as

❯ Niall Sweeney

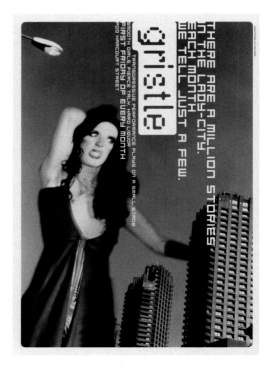

much about masks and spectacle as any drag queen is about architecture" he adds, laughing. "It's all a bit Situationist really – running around a city is much the same as running around a nightclub, drunk or otherwise, and I spend most of my time in both. Cities are reservoirs of memory and fantasy, and I run around trying to remember and fantasise. I think drag and performance form some kind of medium between us and our urbanity – and I enjoy the stories that unfold. It's a notion that I am applying at the moment in a series of posters and promotional material for Gristle, a monthly performance event. I have literally mapped one kind of my images onto another, and let what happens happen, with very little manipulation. The performers were specifically shot in action, and then I married them to my city shots. They create a kind of mediated metropolis."

The actual photographs that Sweeney takes may themselves never make it to the final piece of work that they were part of the process of making – Sweeney emphasises that his process is still very manual, even though the medium is digital. The photographs may just form part of the series of sketches and provide a means of exploring ideas. They may also become radically altered along the way. Quite often Sweeney's photographs will form the basis of a drawing, which is then used as a further means of processing images. His flyers and advertising for the club HAM (Homo Action Movies) in Dublin and one of its sister clubs, Knock Off in New York, use this technique. Sweeney traces over photographs, then traces over these tracings, again and again until a line drawing emerges that lies somewhere between a cold photo-tracing and a manual 'live' drawing. He then uses these 'empty' beings as digital masks to be placed over different materials such as lace, silk, thread and wood veneers. These materials are scanned directly, as you would a transparency. The results have a camouflaged or veiled appearance. The mask and projection are what you become in a club, he says. "In Clubland, the surface is the substrate, and vice versa. It's like in the city at night, it's the lights that are concrete, not the walls that support them. The work I do for HAM naturally extends beyond print into projections, themes and storytelling." Sweeney

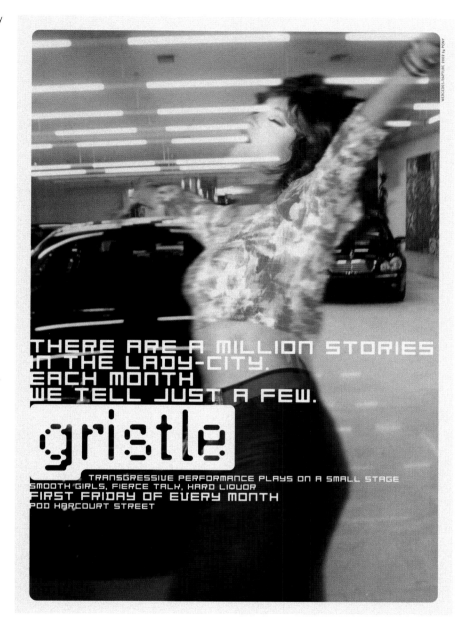

THERE ARE A MILLION STORIES IN THE LADY-CITY. EACH MONTH WE TELL JUST A FEW.

gristle

TRANSGRESSIVE PERFORMANCE PLAYS ON A SMALL STAGE
SMOOTH GIRLS, FIERCE TALK, HARD LIQUOR
FIRST FRIDAY OF EVERY MONTH
POD HARCOURT STREET

GRISTLE DRAG AND PERFORMANCE EVENT, DUBLIN, 2002
IN THIS PROMOTIONAL DRIVE FOR GRISTLE, SWEENEY
COMBINED IMAGES OF DRAG QUEENS WITH THOSE OF CITIES

ILLUSTRATING HIS BELIEF THAT DRAG FORMS A LINK BETWEEN
THE VIEWER AND URBANITY.

continues: "Clubs provide an amazing continuity of change. I have been working with HAM for five years, so the stories grow and get richer. Last year [2001] the ads consisted of short stories, which I also wrote. Flowery, purple, optimistic dirty stories – sex, friendship, betrayal, snogging and some black chick singing on the stereo – all based on my own and perceived friendships and experiences – coupled with 'really bad' drawings [from tiny photos] blown up out of all proportion. You don't often get that investment in design, that romance. Romance is such a great thing, and it pays. Love is the drug. And the absolutely personal is most often the most universal."

"I love the potential for unexpected or impossible movement in a still image. You remember when you were sick, way back when you were a kid before daytime TV even existed, and the test-card transmission was on and there she was, that girl, drawing on that blackboard like she'd won the bloody peace prize, with the skull and the dog. And you watched it, and that sound, that tone was so hypnotic. Now just imagine that she winked at you. Just once, once in your entire lifetime. What does that do to you? I love the potential for that in a photograph. What if you had just not been looking at that moment? What is happening right now behind you? Because every time you look at a photo, that's what really happens in your head. Those lips parted, that eye blinked, that dog barked in the distance. Who is that, there, just out of shot? Just like any memory you have – each stored as a Polaroid, but with limited and looping motion. I remember when the web was just kicking in, way back in 1992, and that C-U-SEE-ME application was out. It was way before webcam stuff and was in lovely black and white, and there were all these live video feeds of people's desks, empty chairs and offices at night because they had left all the gear on."

Sweeney searches for these moments and uses both his design knowledge and computer applications to push these real moments into a surreal situation via photography. Consequently, Sweeney creates work that is truly original by playing on visual conventions to tell a story that resonates with the end user.

WORK IN PROGRESS AND FLYERS FOR HAM CLUB NIGHT, DUBLIN, 1997–2002
SWEENEY USED MATERIALS PLACED ON TOP OF THE SCANNER TO PRODUCE A SERIES OF UNIQUE TEXTURED IMAGES. HE USED A SIMILAR TECHNIQUE FOR KNOCK-OFF, THE VENTURE'S SISTER CLUB IN NEW YORK.

 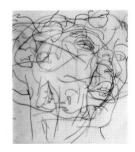

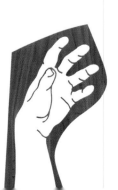

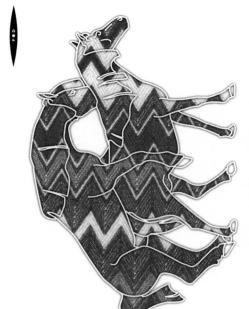

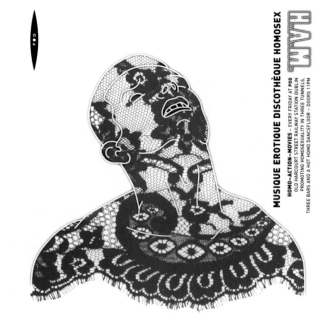
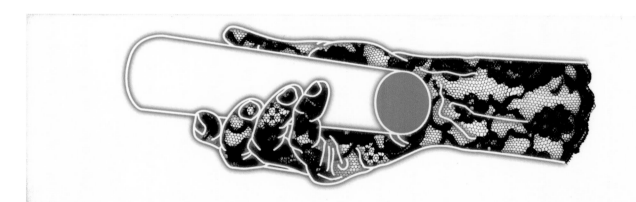
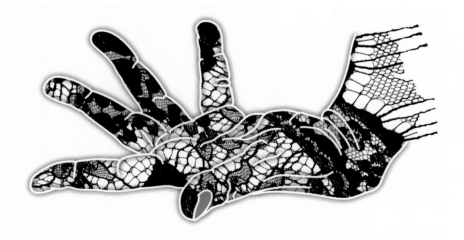

Niall Sweeney

〉 Real-time project

Client: D1 Recordings
Job: CD and Gatefold Vinyl release of *Passing Through* by Visitor

Overview:
D1 Recordings is an independent record label with offices in Dublin, London and Detroit. It releases a number of its own recordings each year, and also handles other releases through its distribution company. In general, the recordings are released in a generic D1 sleeve, which itself changes about once a year. Although D1 has already released some tracks on this label, the band Visitor (Mark Broom and Dave Hill) was turning into something of an ongoing project for D1 – Broom and Hill have been doing DJ gigs at D1's event *Made* In Dublin for some time – so Sweeney's brief was not only to design this release, but to develop it as the start of an ongoing identity for all Visitor projects with D1.

May 2001
Every few months, Sweeney gets a general schedule of upcoming D1 activities. He had plenty of forewarning that this project was coming, so he

"I see my work as a way of making mnemonics for memories you haven't had yet. That's why I take photographs. It's like map-making for undiscovered territories."

D1 RECORDINGS: VISITOR, 2001
TO PERPETUATE THE THEME OF TRAVEL IN THIS PROJECT, SWEENEY TOOK A SERIES OF PHOTOGRAPHS (RIGHT) IN LONDON, BARCELONA AND DUBLIN, WHICH CONVEY THE

FEELING OF 'PASSING THROUGH'. HE COMBINES THIS ORIGINAL PHOTOGRAPHY WITH GRAPHIC SYMBOLS AND WEATHER CONTOUR MAPS (LEFT) TO FURTHER ENHANCE THIS IDEA.

knew from the start the length of time that this project would take. The design schedule was devised as three, roughly month-long, blocks of work, which were spread out over 12 months. This allowed the design work to develop in parallel to the recordings, culminating in the release, the working title of which was *Past – Present – Future*. The brief was to visually express Visitor's name, its musical output in general and that specific to this release. Sweeney was also asked to express the band's contextural development in terms of its relationship with D1.

An interesting aspect of this project was the initial exchange of ideas. Rather than passing images or music back and forth, D1 sent Sweeney an old Irish short story, *The Visit*, as a starting point. Sweeney responded with some further texts that dealt with similar and connected issues. So this first stage of development was an exchange of stories. This was in itself a reflection of the project, as Visitor was travelling between London and Dublin and further afield, such as to Barcelona, on D1 recording projects and events. Sweeney developed a number of sketchbook ideas at this time in response to the texts and

discussions the groups had exchanged about the release. Sketches were discussed in a basic, raw form as a means of developing the brief further. As none of the tracks had been recorded at this stage, D1, Visitor and Sweeney decided to wait until that work had begun before proceeding further, as it would inevitably influence the design work.

September 2001
After some of the first tracks were laid down, Sweeney undertook a period of travel – some of which was specifically done as developmental research. Over a few weeks, Sweeney visited London, Barcelona, Dublin and the far-west coast of Ireland, shooting images and trying to find resonance with the brief and to develop the initial ideas.

The contact sheets yielded some great 'stories', showing openings, grids, shadows, the palimpsest nature of urban development and even political stencil-graffiti (which linked back to some of the original sketches). There were also many shots of clouds lost in open skies. For Sweeney, travel also yields a great deal of statistical information – times, positions, heights, repeat occurrences,

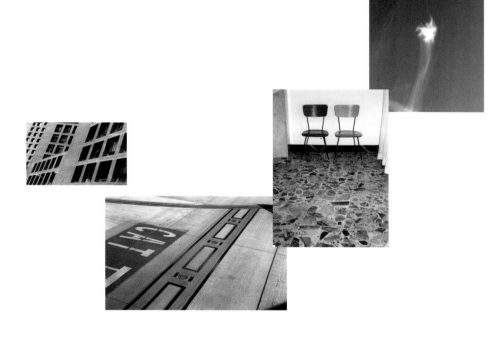

patterns and contour maps, for example – and this seemed to be the key linking the music and the theory as it made connections between aural and actual spatial experiences. This was also a period of processing, editing and transposing narratives, images and graphs onto one another, to create kinds of maps.

At this stage, the title of the release was changed to *Passing Through*, which actually gelled the project for Sweeney in terms of its direction, and a very specific suite of processes and information representation developed. Eventually Sweeney was using the CMYK inks not to replicate a photo (fiction) but as flat inks of overprinted information (fact).

By this point, Sweeney had to wait until all of the tracks were down. This gave him an unusually long period to reflect on where the project was going.

March 2002
With the recordings secured, Sweeney could finally work with hard factual information relating to the recordings, and marry these to the more poetic aspects of the imagery and typographic approaches developed so far. These included, in Sweeney's own words, "the grids that our cities are extruded from, plans of parking lots, motorways and roundabouts and then these contour maps of clouds and puffs of smoke." It was only at this stage that the physical forms of the CD and vinyl packaging had any impact on what was to be printed on them and that actual-size mock-ups and proofs were made. This was a very quick process when it came to it. Sweeney describes it as "like 'dipping' the blank forms into this rich reservoir of visual language that had been developed over the last 12 months." The design consisted of ideas and methodologies that had matured gently in plenty of time. Thus, it managed to remain an intuitive event despite a lead time of ten months. The remaining work developed will go on to inform the visual language of Visitor projects with D1 in the future, the next of which is a release in Russia.

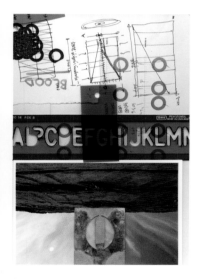 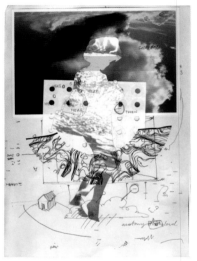

D1 RECORDINGS: VISITOR, 2001
TO FURTHER ENHANCE THE THEME OF TRAVEL, SWEENEY USED
CONTOUR MAPS COMBINDED WITH MAP CO-ORDINATES TO
CREATE FREE FORM SHAPES. SOME OF THESE SHAPES WERE

DIGITALLY CONTORTED TO FIT ONTO PHOTOGRAPHS OF CHAIRS
HE HAD TAKEN. FOR SWEENEY, AN EMPTY CHAIR SIGNIFIES
THE LONE TRAVELLER WAITING IN AN EMPTY WAITING ROOM
FOR THE NEXT STAGE OF THEIR JOURNEY.

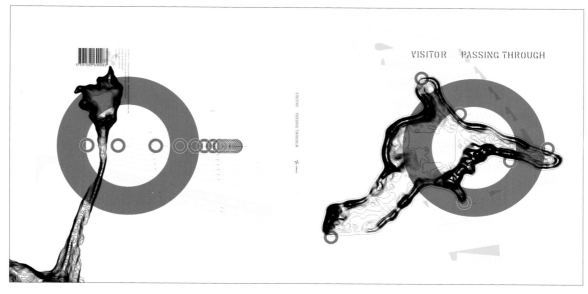

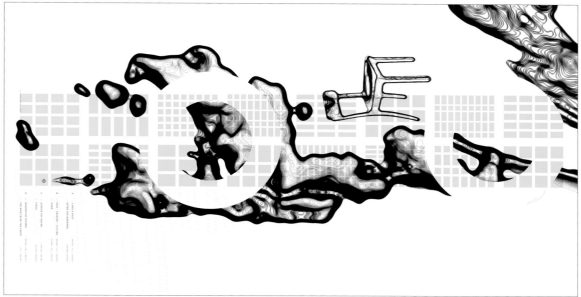

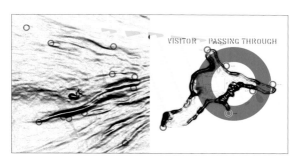

2

Established designers

Established designers

This second chapter considers a number of established designers who retain an unusually strong urge to be creatively inventive within the commercial sphere. Many of the designers featured here have relationships with clients that are exceptional for the amount of trust that exists between the two parties. These designers are not considered to be suppliers by their clients, but are seen as associates – part of the team. They frequently share in the strategic planning and work as 'underground problem solvers', unearthing the client's brand story and crafting the visual means to sell a persuasive and accessible message. Stefan Sagmeister, for example, talks of his personal and professional relationship with fashion designer Anni Kuan and how, with this trust and knowledge, he is available to create bespoke literature for her company that appeals to the retail buyers who work with her regularly.

These established designers have a realistic attitude towards self-initiating elements. Jake Tilson reveals why he uses his own photography in his designs to create a bespoke campaign: "A designer who self-initiates elements makes themselves more valuable to certain clients by cutting down commissioning, streamlining the process and reducing copyright issues. [Self-initiating] also enables a designer to control and expand the breadth of their design."

Tilson began taking his own photographs to free his work from the baggage and associations of found images. Sandro Sodano of Aboud Sodano began taking pictures when a client urgently needed a photographer. Now Sodano operates as a photographer, and, with his art director partner Alan Aboud, is responsible for campaigns for clients such as UK fashion designer Paul Smith. "The benefits of self-initiation are mainly time and speed," says Aboud. "There isn't the rigmarole of meeting a freelancer and trying to get your ideas over. Sandro and I both work on the concept together, so this cuts out weeks of going back and forth.

Content is another issue that concerns those featured in this chapter. Many talk of the value of original, appropriate and challenging content,

and how ideas, strategy and copy contribute to strong graphics. Examples of this include Manss' literature for B&W Speakers. He views part of his role on this project as an author because of the narrative that unfolds through the design and the photography. "The design tells a story rather than just consisting of some type being pushed around until it looks pretty," says Manss. "It proves that design is not just about style. Style is to graphic design what ornithology is to birds."

As more established designers, these contributors are able to select their clients and the content they're given, and they often help to initiate that content themselves. For example, Fuel was responsible for generating all the elements – from words, content, design and animation – in its title sequences for the Sci-Fi Channel.

For these designers, realising the design is just a part of the process after the brainstorming and researching, and is not their only concern. Many of the designers in this section complete personal projects: for example, Barnbrook's guest contribution for South Korea magazine *Design Monthly*; Sagmeister's charity pin produced in commemoration of the September 11th disaster in New York; Fuel's self-published concept books; and Manss' personal notebooks. Sagmeister recently took a year off from clients in order to refresh his attitude towards design, as he felt his work was becoming repetitive.

These designers question how and why they design, and are able to explain and justify the practical and intellectual processes they use to devise a design solution. They use personal projects to inspire their commercial work, and manage to balance the two. The use of self-initiated elements in their commercial work is a natural extension of this.

Many of these designers are also involved in education. Teaching allows them to give something back, as well as to explore new ideas, mediums and modes of production. Most admit that there is nothing like a room full of bright, questioning students to challenge conventional wisdom and ways of working.

**Peter Miles, Damon Murray and Stephen Sorrell
of Fuel, London**

Peter Miles, Damon Murray and Stephen Sorrell
have worked together as graphic design group
Fuel since 1991, when they were students at the
Royal College of Art.

Fuel's collective aim from the beginning was
to combine commercial commissions with projects
of their own, although, as Murray says: "There are
no hard and fast rules about how much we self-
initiate on commercial projects, as the brief dictates
this. The most obvious self-initiated aspect of our
work is that it is very ideas- and language-led."

Sorrell continues: "We get most of our work
through word-of-mouth, as our work is particular
to us. We never categorise our work – that can
restrict the way you view something."

One example of Fuel's creative process and
commissioning practice was the series of idents
produced for the global Sci-Fi Channel. The
commissioner, Michael Barry of Universal Studios
Networks, had wanted to work with Fuel for about
two years. "He likes our work and simply asked us
to produce what we do," says Miles. "It was our
personal work that was our main influence; our
film knowledge is purely self-taught."

Fuel's previous film experience includes
commercials for Cellnet First and the Heathrow
Express. In 1999, it designed the logo and idents
for MusicLink, a TV Music Channel for Sony in
Japan, and in 1998 devised a series of short
experimental films under the title 'Original Copies'
that was shown at international film festivals and
broadcast on the UK's Channel 4. These films
received an Honorary Mention at the Prix Arts
Electronics in 1999, while Fuel's idents for MTV
Europe were nominated for a D&AD Silver in 1994.

The Sci-Fi Channel brief was very flexible; the
idents were to have a philosophical and scientific
feel that challenged any audience preconception
that the network caters solely for the traditional
science fiction enthusiast, since the channel sees
its viewers as perceptive and questioning. The
six 20-second idents in five languages were shown
between ad breaks. Occasionally, in the UK,
the channel broadcast a foreign version just to
throw viewers.

Fuel's solution developed from an animated
type sequence that it had self-initiated as a
personal project. Fuel was responsible for all
design, production and animation and, with the
writer Shannan Peckham, the trio considered
topics and issues to be covered in the work that
would develop the channel's own graphic language.
Advertising was the starting theme and, as the
group refined the words, the messages and
products became increasingly subliminal. It took
six weeks to refine the words into succinct
messages. Following this, Fuel had to calculate the
spacing so that the filming would be accurate and
the messages readable. "It was vital that the
reader would be able to read them but also that
they would be enigmatic enough for repeated
viewing," explains Miles.

The design trio chose Univers, feeling that the
job required a very simple font that could be read
easily when animated. Says Murray: "The colours
were very important. While those selected for the
UK were very crisp and bright, the ones for mainland
Europe needed to have more blue tones due to
the darker content of the European division."

Fuel rejected musical accompaniment as it felt
that music was "too usual and expected". Instead
sounds were created and sampled by sound
designer Sebastian Sharples under the guidance
of Fuel. According to Murray: "Spacing, sound and
pace had to be tweaked for the different versions,
as a small word in English might constitute three
words in Spanish or a single long word in German."

STILL TAKEN FROM 'ORIGINAL COPIES', 1998
'ORIGINAL COPIES' WAS AN ANIMATED TYPE SERIES OF SHORT
FILMS CREATED BY FUEL THAT WERE BROADCAST ON CHANNEL 4.

THIS PERSONAL WORK DIRECTLY INFLUENCED THE WINNING OF
THE SCI-FI CHANNEL COMMISSION.

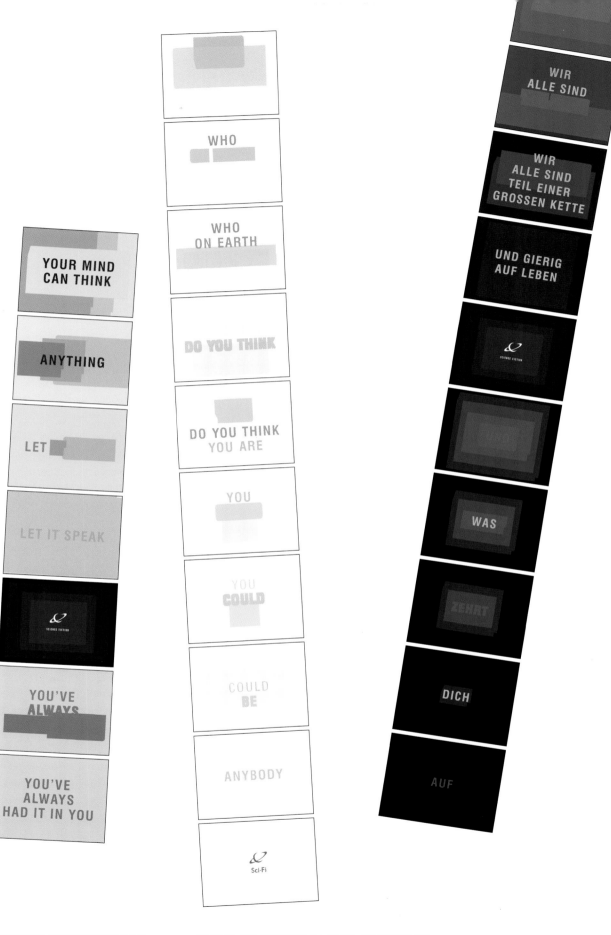

SCI-FI CHANNEL IDENT TEST FRAMES FROM ORIGINAL PROPOSAL, 2001

THE IMAGES REVEAL A FRAME-BY-FRAME DEVELOPMENT OF FUEL'S IDEA OF SHOWING MELTING TYPE TO COMPLETE THE MESSAGE. FUEL GENERATED ALL DESIGN, PRODUCTION AND ANIMATION TO CREATE BOTH A DESIGN AND GRAPHIC LANGUAGE THAT WAS UNIQUE TO THE BROADCASTER AND WHICH WORKED IN FIVE DIFFERENT NATIONAL MARKETS.

In 1996 *Pure Fuel* was published – a personal graphic exploration of topics such as function, leisure, chaos, society and space. Fuel's second book, *Fuel 3000*, published in 2000, offered a composition of contemporary obsessions and addressed the concepts of memory, jealousy and choice. The books use a combination of photography, film stills, drawings and typography to build up a sustained sequence of ideas.

It was Fuel's books that inspired advertising agency creatives at Bartle Bogle Hegarty to commission the trio to create a European print campaign for the launch of Microsoft's new games console XBOX. Fuel was given ideas in the form of basic sketches by BBH. Sorrell explains: "We

"Most designers think the whole graphic authorship debate is worthless and most don't do work of their own unless they are getting paid for it. But self-initiated work is not a bad thing because it expands the language of graphic design."

PAGES FROM *PURE FUEL*, 1996
THESE PAGES FROM FUEL'S FIRST SELF-PUBLISHED BOOK *PURE FUEL* SHOW THE TRIO'S STARK AND INNOVATIVE PHOTOGRAPHY. THE BOOK WAS PICKED UP BY A TEAM OF ADVERTISING CREATIVES, WHO COMMISSIONED FUEL TO TAKE THIS SELF-INITIATED WORK AND TRANSFORM IT INTO A PRINT

ADVERTISING CAMPAIGN FOR THE LAUNCH OF MICROSOFT XBOX. FUEL SEE THAT BOTH THIS AND THE SCI-FI CHANNEL COMMISSION ALLOWED IT TO RESPOND TO A BRIEF WHILE RETAINING ITS PERSONALITY.

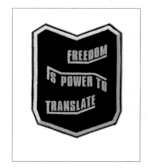

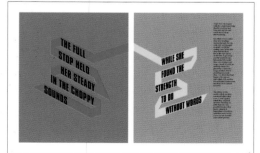

FUEL 3000 BADGE, 2000
THIS BADGE, 'FREEDOM IS THE POWER TO TRANSLATE', IS FROM FUEL'S SECOND BOOK *FUEL 3000*. MILES, MURRAY AND SORRELL WORKED WITH A MYRIAD OF SELF-GENERATED TECHNIQUES SUCH AS FILM, DRAWING, PHOTOGRAPHY, TYPOGRAPHY AND NEEDLEPOINT TO CREATE A PERPETUAL SERIES OF IDEAS.

FUEL 3000 'THE FULL STOP HELD...' SPREAD, 2000
THIS SPREAD FUSED GRAPHICS AND TEXT TO CONVEY OBSESSION. IT READS, "THE FULL STOP HELD HER STEADY IN THE CHOPPY SOUNDS WHILE SHE FOUND THE STRENGTH TO DO WITHOUT WORDS."

wanted quite a raw, spontaneous feel to the campaign so that the youth market did not immediately dismiss the ideas as obvious. The set-ups needed to look as real and natural as possible and the snapshot quality of the pictures helps this."

Fuel took all the photographs for the campaign, art directing themselves as they had done previously in their personal work. The design of the ads also has a strong typographic element, in the style of the Fuel books. The use of type and image is bold but the composition retains harmony.

"Personal work exists alongside graphic authorship," explains Sorrell. "We have always done our own work but the term was applied to it by journalists. We believe that there is no reason why graphics can't be used as a tool for what you want to say. With our personal work we are the client, commissioner and executioner. But the Sci-Fi idents and XBOX campaign responded to a brief while retaining a feeling of our personal work."

Concludes Miles: "Most designers think the whole graphic authorship debate is worthless and most don't do work of their own unless they are getting paid for it. But self-initiated work is not a bad thing because it expands the language of graphic design."

XBOX ADVERTISING CAMPAIGN, 2002
FUEL WAS RESPONSIBLE FOR THE PHOTOGRAPHY, ART DIRECTION AND DESIGN OF THIS PART OF THE XBOX ADVERTISING CAMPAIGN. THEIR ADDITIONAL SKILLS IN THE USE OF LANGUAGE IN THEIR DESIGNS IS MUCH APPARENT HERE.

Jonathan Barnbrook, London

Designer Jonathan Barnbrook established his eponymously named studio upon graduation from the Royal College of Art in 1990. His client and collaboration list includes: fine artist Damien Hirst; Booth-Clibborn Editions; the Saatchi Gallery; the Barbican Arts Centre; *Adbusters* magazine; Los Angeles' Museum of Contemporary Art; the UK's White Cube Gallery and Japanese clothing company Beams.

Barnbrook's main specialism is the creation of his own typefaces, which are sold through his foundry Virus and used in both personal and commercial projects. "Clients rarely commission typefaces," says Barnbrook. "But I have designed several as personal projects that have been picked up by clients. The benefit of working without a brief is that the process is organic as opposed to being determined by the commission."

The earliest example of this is his design of his first book, *Illustration Now – The Best of European Illustration,* published by Booth-Clibborn Editions in 1995, where Booth-Clibborn commissioned the work to use Exocet. "Self-motivated projects mean that the resulting work is more connected to your world," explains Barnbrook, "and what you create is more of an emotional and honest response to what is going on around you." To convey his anti-capitalist ideology and the emotions aroused by the Gulf War, Barnbrook used a combination of cheesy stock photography, his Exocet typeface, and found ephemera. The cover design considered consumerism by showing a gold credit card in the hands of a saint. A photograph of baked beans was used as a background reference to make the book look like an obvious commodity.

Exocet was devised three months earlier as a personal project and is based on early Greek stone carvings. "I made drawings in the British Museum and some elements, such as the stem of the 'E', were directly translated into the typeface. I wanted to create something that evoked the aesthetic of letterforms and that also spoke in the spirit of the time," he explains.

The Koran and barcodes inspired the introduction pages, and Barnbrook also designed a series of divider pages to further explore his concept. One showed students as the new

Jonathan Barnbrook

ILLUSTRATION NOW – THE BEST OF EUROPEAN ILLUSTRATION, 1995
BARNBROOK'S THEMED DESIGN FOR THIS BOOK CONSIDERS HOW
EUROPE MARKETS ITSELF WITH COPIOUS REFERENCES TO
CONSUMERISM, WAR AND OBSESSION WITH OIL. IN ADDITION
TO THE DESIGN, BARNBROOK USED A BESPOKE TYPEFACE
CALLED EXOCET, NOW AVAILABLE THROUGH EMIGRE. IN THIS
WORK, BARNBROOK USES EXOCET SO GRAPHICALLY THAT THE
LETTERFORM'S SYMBOLIC MEANING BECOMES SECONDARY

TO ITS ADDITION TO THE DESIGN COMPOSITION. THE
COPPERPLATE-STYLE FONT, ALSO DESIGNED BY BARNBROOK
AND CALLED FALSE IDOL, SUBTLY CONTRASTS WITH THE
CLASSICAL LINES OF EXOCET, CARRYING THE PAGE'S
TEXTURAL CONTENT.

E

⊕

C

E

+

F N

+ S

A B C D E F G H I J K L M

N ⊕ P Q R S + U V W X Z

Jonathan Barnbrook

2 Established designers

EXOCET TYPEFACE, 1993
EXOCET HAS PROVED A VERY POPULAR TYPEFACE, ESPECIALLY
WITH FONT PIRATES, ILLEGAL INTERNET SITES AND COMPUTER
GAMES MANUFACTURERS. BASED ON DRAWINGS MADE FROM
EARLY GREEK AND ROMAN STONE CARVINGS, THE FONT WAS
PUT INTO A CONTEMPORARY CONTEXT WHEN IT WAS DRAWN ON
THE MAC. BARNBROOK IS UNSURE WHY THE FONT HAS BEEN
SO POPULAR WITH THOSE UNWILLING TO PAY FOR ITS USE, BUT

HE BELIEVES IT COULD BE SOMETHING TO DO WITH THE
HISTORIC REFERENCES IN THE LETTERFORMS. HE CONTINUES,
"I'M VERY INTERESTED IN THE HISTORY OF TYPOGRAPHY. IN
EXOCET THE REFERENCE COMES FROM PRIMITIVE GREEK AND
ROMAN STONE CARVINGS. HOWEVER, IT STILL LOOKS
CONTEMPORARY. THERE'S A STRENGTH IN THE SHAPE OF THE
LETTERS, AND IT LOOKS KIND OF NASTY AS WELL AS HINTING
AT AUTHORITY."

Same Original Character Designs

EXPLETIVE TYPEFACE, 2001

EXPLETIVE SCRIPT IS A MODULAR FONT BASED ON A CIRCULAR
FORM, WHICH ALLOWS THE CHARACTERS TO SIT ABOVE AND
BELOW THE BASELINE. THE TYPE SPECIMEN HERE ECHOES

THE DESIGN OF A STITCHED SAMPLER, WHICH OFFSETS
THE IMPLICATIONS OF VIOLENCE DESIGNED INTO
THE LETTERFORMS.

"'Graphic authorship' and 'self-initiation' are phrases coined
by designers who see a separation between public and private
work, and we don't."

consumers with Father Christmas in the background; another hides the BBC logo. "The brief was very open," says Barnbrook, smiling, "often the advantage of low-budget projects is the extra freedom – almost like a self-initiated project."

Barnbrook utilised his font design skills again for a commercial project for the Museum of Contemporary Art in California last year. 'Public Offerings' was an exhibition of nineties contemporary art collated from across the globe. For the cover of the catalogue and posters he drew the word 'Public' on in lettering that was to become the Expletive font after the event. It is a script font based on a circular form with characters that go above and below the baseline. The name 'Expletive' comments on the possibility for violence in language.

Barnbrook received the commission from the museum directly because they had seen his work for Damien Hirst and the White Cube Gallery. "The catalogue has two fronts, with the essays at one end and the art pieces at the other," he explains. "On this job I introduced a 'no white paper' rule as I am bored of the fact that the pages in art gallery catalogues are always white. To me this always feels like designers are frightened to make a statement with colour that might enhance the work."

Barnbrook never pitches for work or actively sells the company, as the notion of selling makes him visibly cringe. "What is good about us is that we are more of a creative source than a company you just give a brief to," he explains. "And the type of clients we have come to us because of that."

Barnbrook sells three of his fonts through Emigre. The others are Apocalypso, Bastard, Coma, Delux, Drone, Echelon, Expletive, False Idol, Melancholia, Moron, Newspeak, Nixon, Nylon & Draylon, Patriot, Prototype and Prozac, and are available from Virus. He applied his 'Delux' face and "a combination of nasty fonts" to create a "futuristic yet nostalgic" design for the Tokyo Type Directors' Awards in 2001. A Hispanic handbill inspired the poster, while the self-penned text allowed Barnbrook to highlight many of the ethical dilemmas that face designers.

In the main, Barnbrook is inspired by politics and reading, and these influences are heavily evident in his personal projects. A series of spreads for the Korean magazine *Design Monthly* highlights the dictatorship in North Korea as a brand and compares it to the illusions of freedom commonly held in the West. One page in the series plays on the children's illustrative game of 'Spot

'PUBLIC OFFERINGS' EXHIBITION CATALOGUE FOR THE LOS ANGELES MUSEUM OF CONTEMPORARY ART, 2001
'PUBLIC OFFERINGS' WAS A RETROSPECTIVE OF NINETIES CONTEMPORARY ART. BARNBROOK CHOSE TO ELIMINATE WHITE FROM THE BACKGROUNDS OF THE CATALOGUE'S PAGES, FEELING THAT DESIGNERS OFTEN SHIRK FROM COLOURFUL ADDITIONS IN CATALOGUE DESIGN.

the Difference'. In this case, Barnbrook used a social realist painting and replaced a spade in one of the girl's hands with a dagger to show the truth behind the political regime.

But does self-initiation make the resulting work better? According to Barnbrook, "it depends on the job. However, I don't like words or phrases like 'graphic authorship' or 'self-initiation'," he adds. "We do good work but I wouldn't like to define it with terms that could be seen as self-indulgent. What I'm interested in is solving a problem. 'Graphic authorship' and 'self-initiation' are phrases coined by designers who see a separation between public and private work, and we don't. Also isn't everything 'designed'? So therefore everything has a 'graphic author'? We are all products of our time; I wouldn't claim that anybody suddenly revolutionises design with their work."

"Most debates about graphic design are very shallow in this country," he continues. "This is partly because most graphic designers are not historically informed about the subject and therefore I find their own points of view on design rather grey. There are times when I might be an ideological hypocrite but at least I have some ideology."

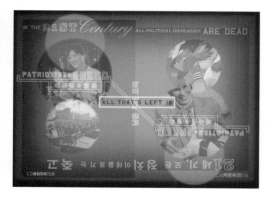

Fig 1. SPOT THE DIFFERENCE 그림 1. 다른 곳을 찾아보세요.

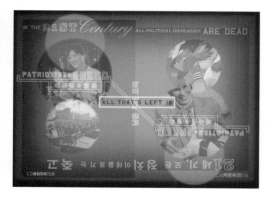

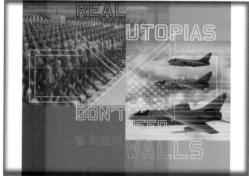

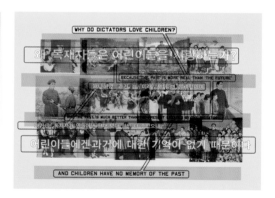

GUEST LAYOUTS ON THE TOPIC OF NORTH KOREA PRODUCED FOR SOUTH KOREAN MAGAZINE *DESIGN MONTHLY*
THIS PROJECT CONSIDERED ISSUES SUCH AS GREED AND MEMORY THAT BARNBROOK CONSIDERS TO HAVE BEEN PROVOKED BY THE STALINIST DICTATORSHIP OF NORTH KOREA. PRODUCED FOR A SOUTH KOREAN MAGAZINE, THE WORK NOT ONLY CRITICISES THE REGIME BUT IT ALSO TALKS ABOUT IDEAS OF FREEDOM AND THE POWER INDIVIDUALS HAVE OVER DICTATORSHIPS. SAYS BARNBROOK: "I AM NOT CONSCIOUS OF USING A CERTAIN AMOUNT OF TYPEFACES – EITHER A LOT OR A FEW. THERE IS NO SPECIFIC ADVANTAGE TO MIXING THEM UP; IT ALL DEPENDS ON THE MESSAGE I AM TRYING TO PUT OVER. ALTHOUGH I THINK THERE IS A CERTAIN WORTH IN THE CONFLICT THAT IS CREATED WHEN YOU USE THINGS THAT ARE DEFINITELY NOT MEANT TO BE TOGETHER. EACH TYPEFACE HAS ITS OWN ATMOSPHERE, ITS OWN ASSOCIATIONS. SOMETIMES IT'S GOOD TO BRING A TYPEFACE INTO A WORK, WITH THEIR ATMOSPHERE IN INVERTED COMMAS."

ECHELON TYPEFACE

A LINEAL FONT BASED ON SIGNAGE SEEN ON GOVERNMENT
BUILDINGS IN CENTRAL EUROPE. THE NAME IS BASED ON THE
SECRET SURVEILLANCE SET UP BY THE UK, AMERICAN AND
AUSTRALASIAN GOVERNMENTS TO POTENTIALLY INTERCEPT THE FAX,
E-MAILS AND TELEPHONE CALLS OF ANY CITIZEN IN THE WORLD.

Jake Tilson, London

Designer and artist Jake Tilson studied painting at Chelsea School of Art and then at the Royal College of Art before embarking on a dual career.

Photography is his most common self-initiated element. Tilson's art is often collage-based and, in the early part of his career, he used to rely heavily on found images and materials. To free his work from the baggage that found material brought with it, Tilson began to experiment with his own photographs and typeset texts in the collages. He has always taken photographs and still uses the same camera he has had for 25 years.

"With commissioned work I enjoy the collaborative process. There is often a specific message to put across and an end user in mind. My approach to making art tends to be more open-ended."

"As a design-studio-of-one I often work for people I know either professionally or as friends. The word-of-mouth approach rather than the pounding-out-of-Powerpoints approach. Solo designers can be at a disadvantage in a pitching

"As a design-studio-of-one I often work for people I know either professionally or as friends. The word-of-mouth approach rather than the pounding-out-of-Powerpoints approach."

Jake Tilson

HAWORTH TOMPKINS ARCHITECTS BROCHURE, 2001
TILSON'S SELF-INITIATED PHOTOGRAPHY FOR ARCHITECTS HAWORTH TOMPKINS' BROCHURE INVOLVED TILSON CAPTURING BOTH UNUSUAL AND CHARACTERISTIC IMAGES AND SCENARIOS IN THE FIRM'S OFFICE. "I OPENED DRAWERS AND TOOK PHOTOGRAPHS OF WHAT WAS CONTAINED WITHIN," HE EXPLAINS. "I ALSO PHOTOGRAPHED UNUSUAL OBJECTS

SUCH AS THE IRONMONGERY FILE. MY AIM WAS TO BRING IN A FLAVOUR OF EVERYDAY WORK AND ACTIVITY IN THEIR STUDIO AND TO HIGHLIGHT OBJECTS AND SITUATIONS THAT APPEAR STRANGE WHEN ISOLATED BUT WOULD ADD AN ELEMENT OF HUMOUR AND IRREVERENCE TO THE FINAL DESIGN." TILSON TWEAKED THE IMAGES IN PHOTOSHOP BEFORE IMPORTING THEM INTO THE LAYOUT FILES.

war because some clients opt for the reassurance a company gives them."

An example of one of Tilson's commissioned projects that reveals how he uses his own photography in his designs is his ongoing work for architects Haworth Tompkins. His first commission was a new business brochure that took two years to complete. In conjunction with this job, he also designed the firm's website.

Says Tilson: "The brochure needed to document Haworth Tompkins' work to date, as the primary audience would be potential clients. Which format to use was our first decision. At one point it was a series of posters that could be compiled to suit a certain client. Eventually we decided upon a small book. The process took a long time as it was Haworth Tompkins' first major advertising. We had to work out what we wanted to say, to who, and how. The editorial team consisted of Haworth Tompkins, myself and the copywriter Sarah Wedderburn. I try to be very proactive with the text and I like to work with copywriters when possible. Sadly, copywriters are usually at the bottom of the client's list."

Haworth Tompkins Architects

7 8 9 10

39 40

11 12

13

ROYAL COURT THEATRE REDEVELOPMENT EXHIBITION, ROYAL COURT THEATRE, 1999
IN CONJUNCTION WITH HAWORTH TOMPKINS, TILSON CO-CREATED AN EXHIBITION AT THE ROYAL COURT THEATRE TO REVEAL THE ARCHITECT'S REDEVELOPMENT PLANS FOR THE BUILDING, AS THERE WAS CONSIDERABLE PUBLIC AND PRESS CONCERN ABOUT THE CHANGES. TILSON TOOK IMAGES OF THE WORK IN PROGRESS AND BROKE DOWN THE BUILDING PROCESS TO CAPTURE VARIOUS ELEMENTS. HE ALSO MADE SOUND RECORDINGS OF THE WORK AND THE BUILDERS' CONVERSATIONS TO PRODUCE A CD. THE DIAGRAMS SHOW HOW THE EXHIBITION SPACE WAS FILLED.

The self-initiated element consisted of Tilson wandering around the client's studio with both his camera and a video camera, taking strange, unusual and interesting images of Haworth Tompkins' office. "I opened drawers and took photographs of what was contained within," explains Tilson.

He continues: "A designer who self-initiates elements makes themselves more valuable to certain clients by cutting down on commissioning, streamlining the process and reducing copyright issues. It also enables a designer to control and expand the breadth of their design. When I'm taking photographs I often think where on the image I might place text and whether I have enough bleed. Photography is an integral part of my design process. When I look through the viewfinder I'm already thinking 'ink' or 'screen'."

Tilson also worked with Haworth Tompkins to create an exhibition at the Royal Court Theatre in London to show the firm's redevelopment of the building. "The exhibition's aim was to explain the design process to the public and press," explains Tilson. "It was a sensitive project as people tend to have a rosy view of the past – it was vital to remind people of what it actually looked like before and how the revised and revealed structure have transformed the theatre."

Tilson visited the Royal Court site office during construction at various times. His photographic approach was exploratory and observational. On a particular visit he made a makeshift table in a derelict garden to photograph various architectural samples and prototypes that lay about the site office. To have organised a carefully lit studio session would have been beyond the budget and the resulting polished shots would have removed the sense of work in progress. Any shortcomings in the photos due to overcast weather or a dusty backdrop could be rectified later in Photoshop. Tilson eventually printed out the photos and text on an inkjet printer and spray-mounted them onto twinflute plastic boards for the exhibition. These boards were pinned to the wall with aluminium push pins bought in New York.

"Another aspect to the exhibition that I added myself were digital audio recordings I made of the Royal Court building site," Tilson continues. "A CD compilation of these were played back during the exhibition. Track one featured the sound of plastering in the rehearsal room with vocal accompaniment from the plasterers, track two was made in the stage area, and track three was of drilling on the top floor."

A selection of the improvisational studio and Royal Court photographs taken by Tilson were later used in an 'Expression of Interest' document he created for Haworth Tompkins. Tilson devised a

HAWORTH TOMPKINS' 'EXPRESSION OF INTEREST' DOCUMENT AND PHOTO LIBRARY CD-ROM, 2001
TILSON HAS COMPILED AN ARCHIVE OF ALL THE IMAGES HE HAS TAKEN ON BEHALF OF HAWORTH TOMPKINS FOR USE IN FURTHER PROMOTIONAL AND NEW BUSINESS LITERATURE. THE EXPRESSIONS OF INTEREST DOCUMENT, FOR EXAMPLE, DRAWS ON APPROPRIATE IMAGES FROM THE LIBRARY WHEN THE FIRM PITCHES FOR A COMMISSION.

"A designer who self-initiates elements makes themselves more valuable to certain clients by cutting down commissioning, streamlining the process and reducing copyright issues."

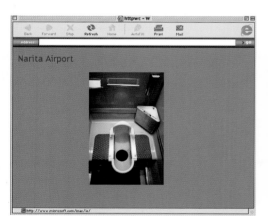

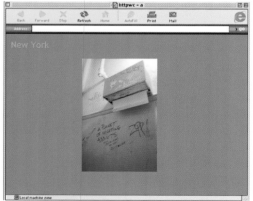

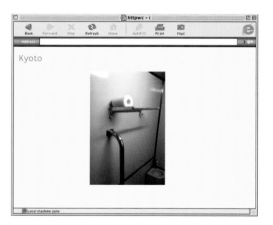

INTERNATIONAL TOILETS PHOTOGRAPHY AS FUSE
TYPEFACE, 1998
TILSON'S LOVE OF THE INCONGRUOUS AND UNEXPECTED IMAGE
HAS LED HIM TO PHOTOGRAPH TOILETS FROM AROUND THE
GLOBE. TILSON HAS LAUNCHED A CD-ROM OF THESE IMAGES
THROUGH FONTSHOP. THE PROJECT CAME ABOUT AFTER

FONTSHOP SAW HIS HTTPWC TYPEFACE IN *FUSE*, THE
TYPOGRAPHY MAGAZINE THAT INVITES A GUEST DESIGNER TO
DEVELOP AN EXPERIMENTAL FONT ESPECIALLY FOR EACH ISSUE.
THE HTTPWC TYPEFACE FEATURES 53 PHOTOGRAPHS OF PUBLIC
CONVENIENCES THAT ARE REALISED BY THE USER CHOOSING
THE FINAL LETTER OF THE TYPEFACE'S WEB ADDRESS.

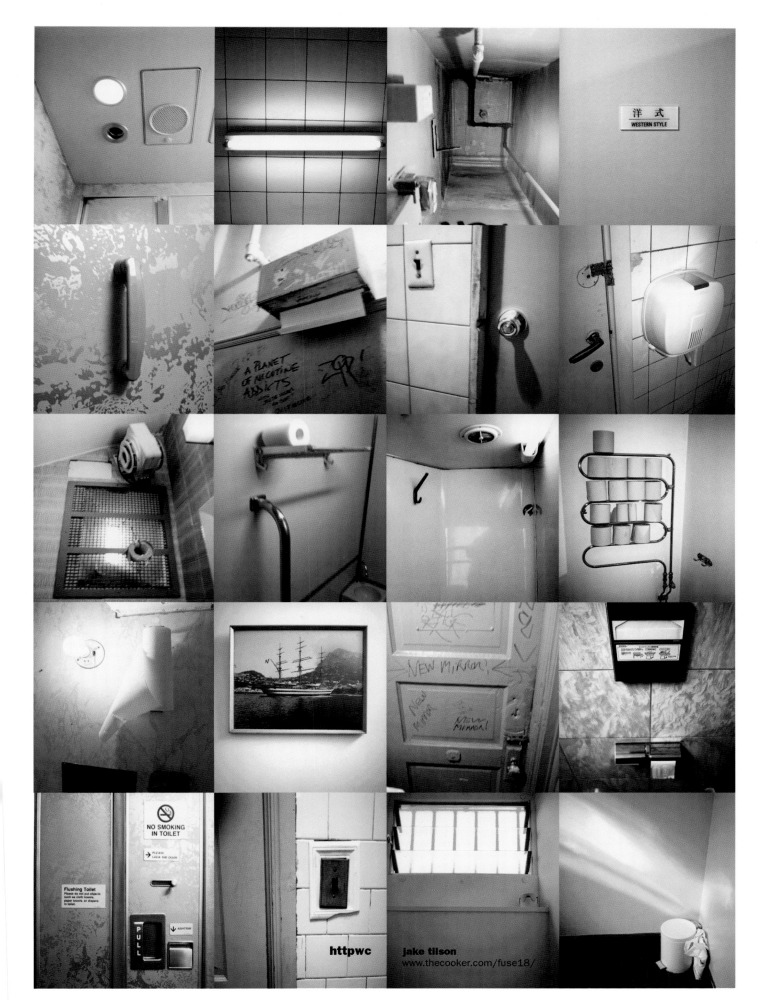

洋式
WESTERN STYLE

A PLANET OF NICOTINE ADDICTS

NEW MIRROR

NO SMOKING IN TOILET

PLEASE LOCK THE DOOR

Flushing Toilet

PULL

ASHTRAY

httpwc

jake tilson
www.thecooker.com/fuse18/

component system for the firm to use when pitching for work. Nexprint in Oxford printed some elements digitally on a Heidelberg Nexpress, one of only four in England. The offset litho covers were printed during an experimental afternoon on a Speedmaster production press at Furnival Press in London, and the appendix section was printed using Haworth Tompkins' in-house inkjets from templates designed by Tilson.

Tilson also designed a website mailer for the firm. In response to the opportunity of some spare space on a print job, he used a photograph of a slide projector remote control and doctored it into a website remote to draw attention to Haworth Tompkins' website.

Although he may seem something of a self-initiation renaissance man, Tilson believes that the key to this type of work is that the designer recognises his or her limitations. Tilson freely admits that he cannot photograph people and would always commission another photographer to undertake this task.

Despite the fact that Tilson rejects the use of stock photography in favour of his own, he has just launched two CD-ROMs of his images through FontShop International. The first CD features photographs of global toilets, from which he selected images to create his experimental Fuse typeface. The second CD, *Urban Noir*, is a collection of Tilson's black and white photographs, which were taken mainly in New York in the eighties. Originally used for his collage art, Tilson is pleased to see the collection get a 'second outing' and being incorporated into other people's work.

'URBAN NOIR' (ONLINE PHOTOLIBRARY PROJECT), FONTSHOP INTERNATIONAL, 1988–2002
ORIGINALLY TAKEN FOR TILSON'S COLLAGE ART, A SERIES OF MONOCHROME PICTURES TAKEN IN NEW YORK 20 YEARS AGO HAVE A NEW LEASE OF LIFE AS A PHOTOLIBRARY CD.

Stefan Sagmeister of Sagmeister Inc, New York

Austrian-born designer Stefan Sagmeister sometimes instigates his own creations for use in his design work as he finds the process "easier and cheaper".

"I only take photographs for my work when quality is not the main issue," he adds. "I think that designers who frequently do their own photography or illustration get trapped in a style that becomes very repetitive."

He continues: "If I do devise every element it is because there is one goal and the elements fit better together. But there is only a certain kind of project that you could physically create all elements for, such as the Spring/Summer 2001 brochure I designed for fashion designer Anni Kuan."

Sagmeister's brief for this project was to do whatever he wanted. Well, Kuan is Sagmeister's girlfriend! "The content consisted of personal stories between the two of us and I used self-initiated photography, illustration and typography to tie the whole concept together. I hand-drew some of the type and then generated some from the computer. It was very well received by Anni's buyers as the content and design were so true to her."

Sagmeister has designed a number of CD covers for New York-based record company Razor & Tie and was commissioned to create the cover for *Gotta Get Over Greta* by The Nields. Sagmeister loved the CD's lyrics and wanted to convey all the aspects and emotions featured in the tracks in the design concept. He took different elements from the lyrics and made little symbols from them. To achieve a layered effect, he cut the booklet short, making both the CD itself and the inlay card visible from the outside. "The hand-drawn illustration definitely makes the design fuller," he feels.

On the whole, however, Sagmeister sees that his clients don't care if the designer self-initiates or not. "They're interested in getting the work done on budget," he adds.

Last year Sagmeister decided to take a year off from commercial work to work solely on personal projects. He did this because he felt his work was "beginning to get a bit repetitive and boring". He elaborates, "For me it was a great little break, but I'm not an artist so I spent my time designing."

He doesn't see his role during this time as justifying the label of 'graphic author'. A designer who earns this title, he believes, is a creator of a self-initiated project where the designer develops the concept. "This doesn't really happen in the commercial world unless you have a patron. I'm not against designers wanting to be known as graphic authors, as I am interested in a complete spectrum of work. I admire Ed Fella's work, and he could be truly described as a singular graphic author as he takes care of every element himself, whereas even my personal work is design. My out-

"I create ideas, styles and forms that are all connected to a commercial design project that might happen at some point."

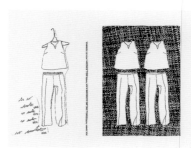

Stefan Sagmeister

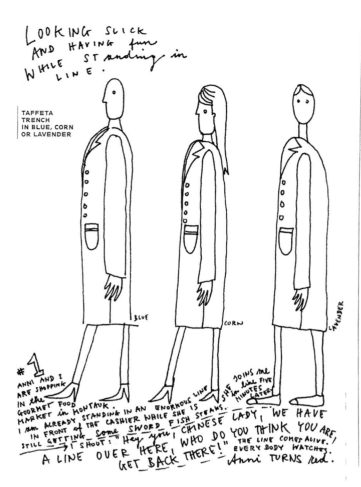

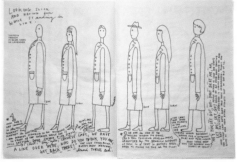

ANNI KUAN SPRING/SUMMER CATALOGUE, 2001
SAGMEISTER WAS GIVEN A COMPLETELY OPEN BRIEF BY HIS
GIRLFRIEND ANNI KUAN. BY USING A HAND-DRAWN AESTHETIC

AUGMENTED WITH PERSONAL ANECDOTES, SAGMEISTER
IMBUED THE CATALOGUE WITH A SENSE OF EXCLUSIVE ACCESS
TO A LIFESTYLE EPITOMISED BY THE CLOTHES ADVERTISED.

WORDS CREDITS

POSSIBLE

THE NEULOS

TITLE

of-office-hours work has nothing to do with exploring my inner. I write a diary sometimes and that's enough exploration for me. I create ideas, styles and forms that are all connected to a commercial design project that might happen at some point."

One self-initiated project Sagmeister did work on is a pin design that is constructed out of metal from the World Trade Center following September 11th. A month after the disaster, 250,000 tonnes of rubble were removed from the site and taken by truck and barge to the Fresh Kills Landfill on Staten Island. It is estimated that ultimately there will be over 1,000,000 tonnes of rubble and Sagmeister needs two tonnes to make 300,000 pins.

The product is an unbreakable two-lobed heart shape that was in use before the last Ice Age by Christians, Jews, Hindus, Buddhists and Muslims. All proceeds will go to a major charity.

"'Graphic authorship' is the buzzword of the moment and is used far too easily," says Sagmeister. "A genuine example would be the products produced by M&Co [the company founded by the late Tibor Kalman]. These projects come under the term graphic authorship but they also formed part of a commercial venture as the products were sold."

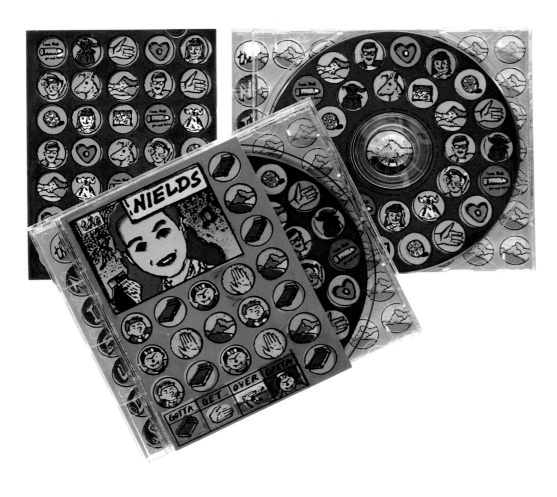

THE NIELDS CD COVER, 1996
FOR THE COVER OF THE *GOTTA GET OVER GRETA* CD BY THE NIELDS, SAGMEISTER UNDERLINED MEMORABLE IMAGES IN THE LYRICS. HE MADE PENCIL DRAWINGS CORRESPONDING TO EACH OF THESE HIGHLIGHTED PHRASES OR WORDS AND PHOTOCOPIED THE ILLUSTRATIONS TO INCREASE THE WEIGHT OF THE PENCIL LINES. THE RESULTING DESIGN WAS INFLUENCED BY THE STYLE OF LOTTERY CARDS FROM THE FIFTIES AND FEATURES WITHIN A SHORT CD BOOKLET TO HIGHLIGHT THE PRINTING ON THE ACTUAL DISK.

He continues: "A number of people draw a line between fine art and commercial design according to if you have a client or not. But Michelangelo was paid for his paintings. Mozart had a king who paid for him to score. I am more comfortable with Brian Eno's theory that it is more helpful to look at a piece of art as an experience rather than as an object. So it is up to the individual to decide whether he or she has had an art experience or not. I've had art experiences in front of a piece of commercial art."

"I've never had the desire to be accepted in the art world," he concludes, "I like contemporary art but prefer being a consumer in that world rather than a doer. To be absolutely honest, I don't give a stuff about graphic authorship."

UNBREAKABLE HEART PIN, 2001
SAGMEISTER SAYS THAT AFTER SEPTEMBER 11TH HE FELT FAIRLY USELESS, AS HE ADMITS THAT HE WOULD "MAKE A VERY BAD FIREMAN OR RESCUE WORKER". AS HIS CONTRIBUTION TO THE RECOVERY, HE CREATED A MEMENTO TO BE WORN IN THE FORM OF AN UNBREAKABLE HEART PIN. THE DESIGN USES THE TWO-LOBED HEART SHAPE THAT WAS IN USE BEFORE THE LAST ICE AGE BY CHRISTIANS, JEWS, HINDUS, BUDDHISTS AND MUSLIMS. ALL PROCEEDS ARE TO GO TO A MAJOR CHARITY. SAGMEISTER ALSO DESIGNED THE PACKAGING, INCLUDING HAND-DRAWING THE TYPE ON THE BOX, WHICH CONVEYS A STRONG ELEMENT OF HUMANITY IN THE PROJECT'S CONCEPT.

"I'm not against designers wanting to be known as graphic authors as I am interested in a complete spectrum of work."

SELF-INITIATED EXPERIMENTAL CD COVERS, 2001

"ONE OF MY AMBITIONS HAS ALWAYS BEEN TO SPEND A YEAR WITHOUT CLIENTS," SAYS SAGMEISTER. AS HE CLAIMS TO HAVE NO DESIRE TO BE AN ARTIST, HE SPENT ONE SUCH YEAR DESIGNING AND EXPERIMENTING WITH NEW THOUGHTS AND PROCESSES IN AN ATTEMPT TO RECHARGE HIS BATTERIES. THESE CD COVERS ARE EXAMPLES OF THE WORK PRODUCED DURING THIS PERIOD.

Russell Warren-Fisher, London

Designer Russell Warren-Fisher believes that his mural for the Hong Kong Telecom exhibition reinforces the idea about how a designer can influence the flavour of the work yet retain the intention of the client.

Pat O'Leary, an ex-student of Warren-Fisher's from Central St Martin's, commissioned the job while at Met Studios on behalf of its client Hong Kong Telecom. O'Leary had seen Warren-Fisher's illustrative work for the British Airways retail outlet in Regent Street and knew of his interest in three-dimensional work.

The brief was very much a two-way discussion and in many ways was inspired by previous commissioned work by Warren-Fisher. The concept for this job had to be futuristic, grand, exciting and communicative while offering a particular fascination for children. It also had to set the tone for the rest of the exhibition as it was the entrance mural.

"I knew what I wanted to see but much of it was just in my head and it relied on me exploring new territories, both in terms of materials and scale," explains Warren-Fisher. "I researched glass opacities and the effects of edge lighting, finally discovering sheet optical glass, which had to be brought over from Germany. The project lasted about four months and involved a great deal of discussion with other specialists such as structural engineers and lighting technicians."

Part of the charm of this commission was that an enormous variety of different components had to be considered. One day Warren-Fisher would find himself designing pictograms for the glass surfaces, the next he was building meter-wide flashing satellite models. "At the time half of my studio looked as you might expect, with Macs on desks, while the rest of it was like the inside of a tool shed. But it is this type of a project that attracted me to graphic design in the first place," he adds.

HONG KONG TELECOM EXHIBITION, 1995
WARREN-FISHER'S MURALS FOR THE HONG KONG TELECOM
EXHIBITION INVOLVED RESEARCH INTO FIBRE OPTICS, SATELLITE
MODELS, FEATURE FILM-LIKE LIGHTING AND ILLUSTRATION.

Russell Warren-Fisher

JAYPARK STUDIOS POSTER WORK IN PROGRESS, 2001
WARREN-FISHER SELECTED FOUR PAPERS IN VARIOUS STATES
OF NATURAL DECAY TO UTILISE AS THE BACKGROUND FOR
THE PROJECT.

For creative reference, Warren-Fisher watched films such as *Blade Runner*, went to see theatre productions just for the lighting effects and visited galleries to see how artists use scale in their work.

According to Warren-Fisher, everything about this project was designed from scratch. It involved an exciting combination of trust from the client, experimentation with materials and a certain amount of educated guess work. "When viewed alongside my other work it perhaps illustrates how important it is to me to vary my response to each new brief. I would like to believe that the common thread running through my work is simply my attitude. I have never subscribed to a 'one size fits all' approach to design. The outcome of any design enquiry should ultimately be dictated by the specific requirements of the brief."

The notion of a 'graphic author' is not a new concept for Warren-Fisher. "Artists have constantly made reference to the tools usually associated with graphic design," he says. "Strangely, it seems easier to justify the knitting together of the two disciplines when coming from an art perspective, but it is equally healthy to see how designers successfully approach commercial problem-solving in this way. The dangers of seeing the boundaries too clearly between art and design have been illustrated throughout history and so, when occasionally we see the emergence of creative minds that are also able to execute their intentions, it helps push the discipline forward. The skill is in gauging the voice of the designer so that it is heard appropriately within the context of the brief."

JAYPARK STUDIOS POSTER, 2001
THE ONLY PROVISION IN THE BRIEF FOR THE JAYPARK STUDIOS POSTER WAS THAT WARREN-FISHER CREATED A PIECE OF DESIGN THAT WOULD FURTHER THE CLIENT'S REPUTATION AS A CREATIVE DIGITAL PHOTOGRAPHER AND EXPOSE AN IMAGE THAT WOULD BE IMPOSSIBLE TO ACHIEVE THROUGH TRADITIONAL PRACTICES. AN IMAGE OF THE SHOWROOM DUMMY AND THE FACE OF THE PHOTOGRAPHER'S ASSISTANT WERE COMBINED DIGITALLY WITH THE BACKGROUND AND TYPE TO PRODUCE A TOTALLY UNIQUE PIECE OF DESIGN.

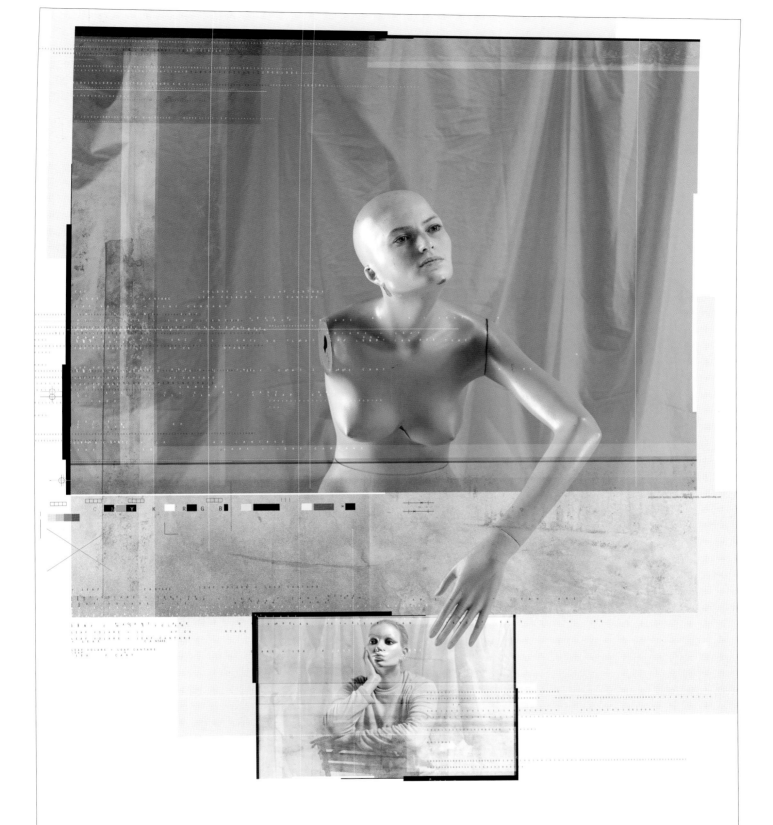

JAYPARK STUDIOS [DIGITAL PHOTOGRAPHY]

T. 01249 655117 / Email. jayparkstudios@btinternet.com / www.jaypark.co.uk

Brunel Park, Vincients Road, Bumpers Farm, Chippenham, Wiltshire SN14 6NQ.

T. 01249 655117 / F. 01249 660740
Email. jayparkstudios@btinternet.com

ISDN. 01249 443274

www.jaypark.co.uk

"Designers are perhaps less aware of their history than they should be. It is very easy to skim through the plethora of glossy design annuals available on the bookshelves and convince ourselves that we understand it," he continues. "The best designers – the ones that enjoy long-term reputations – are those who are well referenced. Their knowledge of the subject shows in their work and in their attitude to the discipline. The 'designer as author' debate continues to get the blood pressure rising among the design purists. One reason being is that it helps perpetuate the celebration of designer as superstar and in doing so conveniently by-passes the relevance of the work."

Warren-Fisher, who is also a part-time lecturer on the MA Communications course at the RCA, describes his work as "a careful balance of formal discipline and a healthy regard for creative freedom".

In terms of originating some of his own material, Warren-Fisher has, over his 13-year-long career, filled scrapbooks with interesting papers and surfaces that now exist in various states of natural decay. When appropriate for commercial jobs, he introduces these findings by scanning them directly into the Mac to see if they will play a part as a unique background for some of his designs. Similarly, the colour palette for a commercial project could have originated from within one of these collections.

An example of this is Warren-Fisher's poster for digital photographers Jaypark. The commission came through the previous job, a brochure for a local printer. The client had asked Warren-Fisher to work with Jaypark on the brochure, who in turn asked Warren-Fisher to create a poster. The job began with an open brief, the only stipulations being that the poster had to appeal to designers, earn Jaypark a reputation as a creative digital photographer and reveal an image that would be difficult to achieve through traditional methods.

"Within the space of a few hours my idea was staring back at me on the screen," says Warren-Fisher. "As the very detailed digital photography was shot in three passes (RGB), it was not suitable for anything other than static objects. This combination of showroom dummy and human face showed that, with the right equipment, incredible accuracy when stitching images together could now be achieved. What's more, the marriage of these two images was totally pixel accurate. The compatibility of this form of digital image-making with Macintosh software meant that I could effortlessly introduce additional layers to the existing image and contribute further to the visual discussion about the process."

For *The Essential Michael Nyman* CD cover, Warren-Fisher combined two Polaroid lifts and placed them onto a prepared canvas that he had painted to achieve texture. The lifts were also over painted and then scanned into Photoshop and combined with type.

"Decca Records were the best client I ever had in terms of trust," says Warren-Fisher. "I was one of a handful of designers who helped to shape the look of the 'Argo' label. It was a testimony to the skill of art director David Smart that he allowed me the freedom to go away and just get on with the design. The briefs were often quite cryptic, with just enough information for me to respond in

"The best designers – the ones that enjoy long-term reputations – are those who are well-referenced. Their knowledge of the subject shows in their work and in their attitude to the discipline."

MICHAEL NYMAN CD, 1993
WARREN-FISHER DESIGNED *THE ESSENTIAL MICHAEL NYMAN* CD COVER FROM SCRATCH. THE PROCESS BEGAN WITH SUPPLIED POLAROIDS. A ROUGH VISUAL WAS FIRST DEVELOPED TO REVEAL BOTH THE IDEA AND THE TECHNIQUE, AND THIS WAS PASSED TO THE CLIENT FOR APPROVAL. TWO OF THE POLAROID IMAGES WERE THEN LIFTED ONTO A PAINTED CANVAS BACKGROUND. IN THE PROCESS, THE FINE SURFACE OF THE IMAGE WRINKLED AND CREASED, ADDING THE FLUID LINES ACROSS THE IMAGE OF NYMAN'S FACE IN THE IMAGE. WARREN-FISHER FINALLY GENERATED TYPE AND COMBINED IT WITH THE BACKGROUND. THE FINISHED RESULT EXHIBITED A HANDMADE QUALITY THAT SUGGESTS AN AUTHENTICITY TO THE CD'S CONTENT.

an appropriate way." The only brief, in this example, was that the cover should feature a picture of Nyman, and Warren-Fisher was unsure that he'd get away with manipulating the composer's face as Nyman had artistic approval.

Ultimately Warren-Fisher sees that there are limitations to self-expression in this way. "As it is non-collaborative, the practice could be accused of being slightly insular. Being responsible for every aspect of the job, however, does mean that the idea remains pure to the end."

Thomas Manss of Thomas Manss & Co, London

German-born Thomas Manss studied graphics at art school in Würzburg and in 1984 entered a poster competition that secured him his first job – although he wasn't the winner. The poster was for the German paper industry, which was worried about the advent of the paperless office. The entry had to promote paper over electronic media. Manss' solution was to photograph a newsreader holding up his notes, with the paper reflecting the RGB slots from the TV screen in front of him.

However, the young Manss wasn't that keen on type and left this element until the last minute, when he found one sheet of Letraset Times New Roman 36pt in his professor's drawer and got his tutor to paste it down. One of the judges, Erik Spiekermann, said that Manss' poster was denied first prize because of bad typography. Manss told Spiekermann that he was rude, and was consequently offered a job at Spiekermann's MetaDesign. He stayed for five years, working on 'huge' corporate identity jobs for clients such as VW and the German Post Office, but was frustrated as all of his friends were doing groovy things like posters and record covers.

A friend of Manss' was teaching typography at Berlin Art School and was due to take a group of students on a trip to London to visit some of the top design consultancies. Manss tagged along and by the end of the trip, in 1989, had a job at Pentagram in London working with Alan Fletcher. He became an associate partner but left the company in 1993 to launch his own operation. His clients include Foster & Partners, Atlantic, B&W, National Art Collections Fund and the British Museum. Coming from a background in running large corporate identity programmes, Manss now feels that he has achieved a healthy balance between identity and editorial work.

Even within high-profile corporate commissions he finds the opportunity to self-initiate elements, mainly using illustration, when the brief requires it. Says Manss: "The process offers total control over the end result. I do self-initiate in many pieces of commissioned work but I do know my limitations. I certainly can't confess to being a star photographer. It's like athletics: if you're a high jumper there is no point in trying to run 100 metres."

He continues: "The fragmentation of the design and advertising industry is evident in some finished work. You can clearly see that the photographer, illustrator, client, copywriter and designer didn't really talk to each other. The result is that many

PAPER POSTER, 1984
MANSS' ENTRY FOR A POSTER COMPETITION ORGANISED
BY THE GERMAN PAPER INDUSTRY, WHICH WON HIM A JOB
AT METADESIGN.

Thomas Manss

Verkehrsverbund Berlin Brandenburg

A thinking man doesn't stay where
he is being taken by chance.
**Ein frei denkender Mensch bleibt nicht
da stehen, wo der Zufall ihn hinstößt.**
Heinrich von Kleist

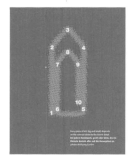
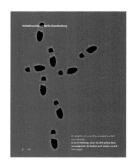
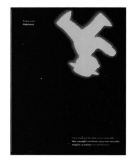

Alan Aboud and Sandro Sodano of Aboud Sodano, London

Alan Aboud and Sandro Sodano met as graphic design students at St Martin's School of Art in the mid-eighties. They graduated in 1989, the height of the recession, with a shared ambition to thwart consultancy convention and do their own thing. A representative from Paul Smith saw Aboud's work at his degree show and hired him as a regular freelance designer. Consequently, Aboud and Sodano founded Aboud Sodano. In need of a photographer for a Paul Smith campaign, Sodano stepped in, shot the images, and his photography career took off.

"The benefits of initiating our own photography are mainly time and speed," says Aboud, explaining how this designer and designer/photographer pairing works. "There isn't the rigmarole of meeting a freelancer and trying to get your ideas over. Sandro and I both work on the concept together, so this cuts out weeks of going back and forth. However, it doesn't make the commission cheaper and some clients automatically think that the photography is part of the overall design fee – which it isn't. Cost should never be a reason for

creating aspects of the brief yourself; for us, it is about creative control and realising the solution we set out to achieve."

"It does make the design better," he continues. "There is automatically a higher starting point than when we work with other people, although I'm not saying that our photography is far better than other photographers' work. We work with other people when we feel the need to draw on the experiences of others."

According to Sodano: "We are very careful to move our work on and reveal versatility. Being able to spot one's work a mile away is not necessarily a good thing, and we have no interest in our work betraying an Aboud Sodano stamp."

For the Paul Smith Spring/Summer and Autumn/Winter 2002 campaigns, Aboud Sodano was given the brief to shoot a fashion initiative where the focus had to be on the clothes and not the models. Instead of simply cropping the model's heads, the duo sought first to shoot scenarios in everyday situations that would create a comfort zone for the viewer and second, to give an everyday nature to the scene's action. This enabled them "to shroud, hide and crop the faces of

Aboud Sodano

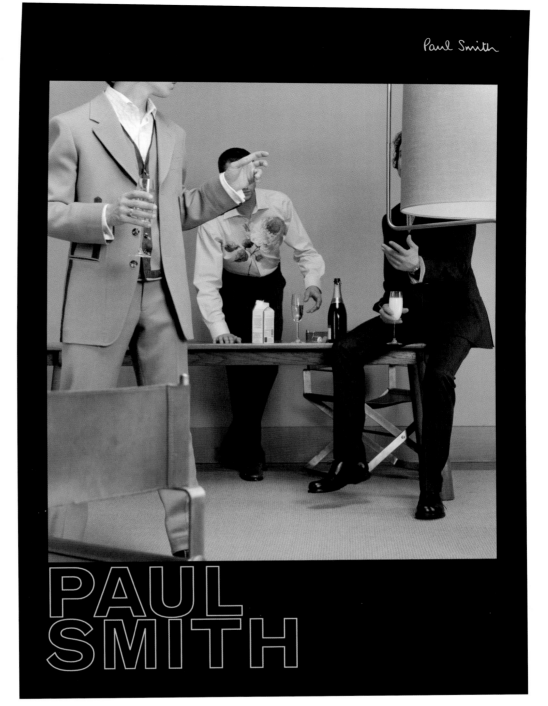

PAUL SMITH AUTUMN/WINTER CAMPAIGN, 2002

ABOUD SODANO HAS WORKED FOR PAUL SMITH SINCE
GRADUATION. THEIR RELATIONSHIP WITH THE PAUL SMITH LABEL
HAS STRONGLY BENEFITTED FROM THE TRUST BUILT UP OVER
THE YEARS, ALLOWING ABOUD SODANO THE FREEDOM TO
EXPERIMENT AND PUSH THE BOUNDARIES OF THE COMPANY'S
CORE IDENTITY RELATIVELY AUTONOMOUSLY. THE SELECTED
IMAGES REVEAL THE PROCESS OF THE MOST RECENT AD
CAMPAIGN FOR THE BRAND, FEATURING IMAGES PHOTOGRAPHED
AND ART DIRECTED BY SODANO.

subjects in a way that was subtle enough that people take a bit of time to notice that it has been done".

"The locations were chosen to reflect certain brand values – luxury, modernity – that represent the most recent collections. The Spring/Summer 2002 collection, 'Rebel Son', was designed around the idea of someone who had an attitude that was healthily irreverent towards beautiful things. This idea of rebellion and irreverence is in every picture, visualised in scenarios such as a pile of rare books being used as a footstool or a rare piece of coloured vinyl as a drinks tray."

In the most recent Autumn/Winter 2002 shoot Aboud Sodano had, in addition to the idea of irreverence, to reflect this collection's themes of opposites and contradictions. One picture shows a man using a shoe to hammer a nail into a wall, while a woman uses pliers to remove a nail from the same, illustrating the concepts of inserting and extracting. In another, a man uses his sleeve to wipe grime from a window while a duster lies unused on the floor next to him, showing the contrast between clean and dirty.

"Cost should never be a reason for creating aspects of the brief yourself; for us, it is about creative control and realising the solution we set out to achieve."

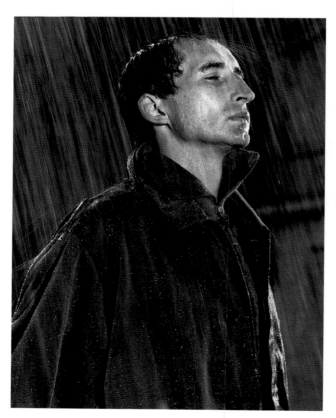
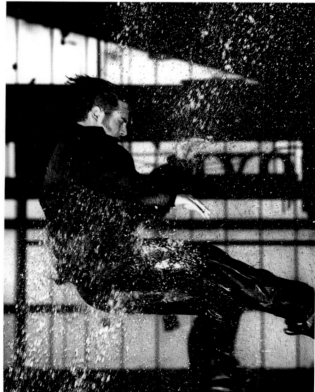

R NEWBOLD CLOTHING LABEL ADVERTISEMENTS, 2000
TO SHOOT STORMY IMAGES TO SHOW THE DURABILITY OF THE CLOTHES, ABOUD SODANO TOOK THEIR PHOTOGRAPHS IN AN OLD DISUSED WAREHOUSE. VOLUNTEERS DONNED THE CLOTHES AND WERE DELUGED BY ARTIFICIALLY GENERATED SNOW AND JETS OF WATER.

A characteristic of all of Sodano's work is that he enjoys problem-solving, which he believes comes from the art director within him. "Paul put so many restrictions on how he wanted the shoot to go that it seemed a daunting task at first. The interiors had to appeal broadly to the customer, the scenarios had to be in no way exclusive or unrealistic, and each picture had to include these ideas of irreverence and/or opposites. Also, the faces had to be excluded or cropped," he explains. "However, I have always found that working with restrictions engenders creativity in finding solutions, and so it would be fair to say that in many ways this project was a true collaboration."

Another Aboud Sodano client is R Newbold, a workwear line that retails in Japan. The line was created from historical records discovered in a workwear factory in Derby founded in 1891. In 2000, the theme of the catalogue was storms, and subsequently resonated with suggestions of toughness, resilience and waterproofing.

To attain a stark graphic image, the pictures were taken by Aboud Sodano in an old disused warehouse. "We hired an industrial snow machine and created a water stunt. We got non-models to wear the clothes and get buffed about by these elements, so the shoot was similar to those Japanese endurance TV programmes," laughs Aboud.

He continues: "The type was very simple, understated and in tune with the graphics. We made shapes with the type and used graphics to create a dramatic impact that matched the pictures. We chose a plastic paper that was impossible to tear and that was waterproof to

carry on the theme of resilience, while the cover was printed onto plastic card."

The pair have also ventured into publishing with two self-initiated books called *The End* and *Growing*. *The End* is a portfolio of a selection of Aboud Sodano's work and is used as a sales and marketing tool. "It will never be for sale," says Aboud, "as I think it's appalling that some designers repackage their own work and sell it."

The second book, *Growing*, features photographs by Dermot Goulding, who was the duo's Head of Photography and mentor when they were at St Martin's. The book shows images of Goulding's son growing up.

Still, Aboud Sodano refuse to see these ventures as graphic authorship. Says Aboud: "Graphic authorship is a bizarre term, as it makes designers seem very self-important. Designers are of an industry, and sometimes you can make statements on other people's money or other people's behalf. Really, we as designers are not that important."

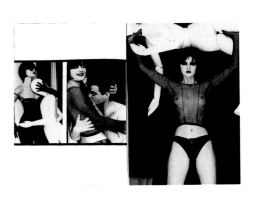

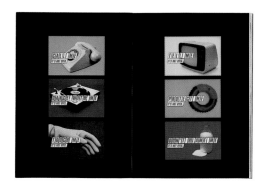

THE END, 2001
AFTER TEN YEARS IN BUSINESS, ABOUD SODANO PUBLISHED *THE END*, A PORTFOLIO IN BOOK FORMAT OF ITS CREATIVE HIGHLIGHTS TO USE AS A NEW BUSINESS TOOL. IT DEMONSTRATES HOW STRONG THE THREAD OF PHOTOGRAPHY IS AS A MEDIUM FOR THESE GRAPHIC DESIGNERS.

Phil Baines, London

Designer Phil Baines completed three out of the required six years' training to become a Catholic priest before opting to study graphic design. He'd always been interested in art and design, and his sister had gone to polytechnic to study fashion; graphic design finally seemed an obvious choice. Baines also presumes that part of his interest in type and letterforms stems from the fact that he has collected road and railway signs since he was 12.

This magpie approach towards signage is very evident in Baines' back garden, which is an Aladdin's cave of railway, tube and public service signage. He's obviously a dab hand at DIY, as his studio is a self-constructed shed in the garden, where above the door a yellow sign from a French café lights up whenever Baines is in residence.

"I've always been fascinated with the fusion of materials with words and I think this inspired my interest in type," Baines explains. "When looking through my foundation course sketchbooks I see that the captions at the bottom of the drawings became increasingly bigger until they became the work."

Baines completed his foundation course at Carlisle before moving on to the BA (Hons) Graphic Design course at Central St Martin's. Following graduation he went to the Royal College of Art in 1985–87 to study for his Masters. While at the RCA, he experimented with letterpress and hand-drawn lettering because the processes gave him more control and he could produce larger letters. He didn't pursue type single-handedly until Neville Brody asked him to design a typeface for *Fuse* (Issue 1) called CanYou(ReadMe)? in 1991.

The proportion of Baines' work for which he has created bespoke typefaces has varied both throughout his career and according to the client's needs. "It is very rare that typefaces come in as commercial projects", says Baines, "but many jobs offer the opportunity to use an existing typeface and improve on it."

Toulon was Baines' first serious type design and was named after the horse that won the St Leger in that year (1991). "My personal brief for Toulon began when I was checking a book on press in Madrid in 1991," explains Baines. "At that time there was no sans serif with thicks and thins apart from Optima, which has a flare problem, and Rotis, which looks great the first time you see it, but later, after one use of it, you realise it's actually hideous."

Baines wanted to reflect the stiffness of road sign lettering in the font; the top of ascenders and bottom of descenders feature a cut that is almost calligraphic. Says Baines: "My first pencil drawings in my sketchbooks considered proportions. I do a fair amount of pencil drawings and doodles to get ideas. I've worked on and refined the typeface over ten years and used it in commercial jobs, when appropriate, as a way of experimenting with it further and the development is paid for by commissions. I first used it in a brochure for 'Catholic', an exhibition I co-curated with Graham Wood at Central Saint Martin's in 1992, and as a result of working on this commission I had the opportunity to test the crispness and clarity of the type, which encouraged me to get rid of the sloping top bowls of 'B' and 'D'."

Baines didn't use Toulon again until 1995, when he designed a poster and gallery guide for Anna and Bernhard Blume for London's Goethe Institute. When he designed posters and guides for other artists in the series of exhibitions, he "used the face very simply and combined it with colour so the design would suggest the work of the artist".

Phil Baines

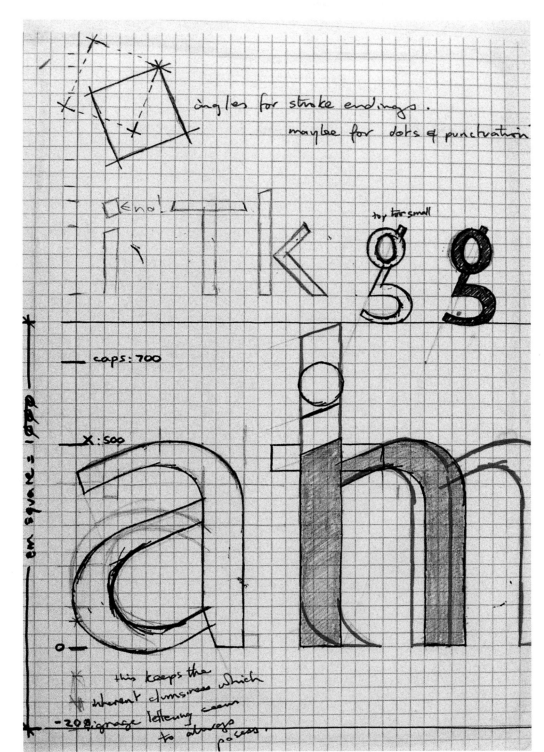

TOULON TYPEFACE, 1991

TOULON – AS WELL AS BEING ONE OF A NUMBER OF FRENCH
PLACE NAMES USED TO TEST EARLY VERSIONS OF THE FONT'S
STANDARD WEIGHT – IS NAMED AFTER THE HORSE THAT WON
THE 1991 ST LEGER; IT ALSO SOUNDED RIGHT. WORKED ON
GRADUALLY, IT WAS FIRST USED IN 1992 FOR THE PUBLICITY
FOR 'CATHOLIC', AN EXHIBITION CO-CURATED WITH EX-STUDENT
GRAHAM WOOD THAT LOOKED AT TYPOGRAPHY FROM CENTRAL

SAINT MARTIN'S COLLEGE OVER THE PRECEDING DECADE.
ALTHOUGH BAINES HAS USED IT SINCE FOR OTHER CLIENTS
SUCH AS LONDON'S GOETHE INSTITUTE AND PARAGON PRESS,
AND ALLOWED EX-STUDENT DESIGN FIRM PRALINE
TO USE IT, HE HAS MAINLY USED IT FOR OTHER PUBLICITY
WORK FOR THE COLLEGE, SUCH AS THE 1996 PROSPECTUS,
2000 SIGNAGE, AND IN THE 2002 EXHIBITION 'MUSEUM IN
THE MAKING'.

"It is very rare that typefaces come in as commercial projects," says Baines, **"but many jobs offer the opportunity to use an existing typeface and improve on it."**

Toulon was also used in the 1997–98 prospectus for Central Saint Martin's, where Baines lectures part-time in typography on the BA (Hons) Graphic Design course and is partly responsible for managing the Central Lettering Record. "In creative terms it is the most proper of all my typefaces," says Baines, "and because it was the first it was the one that needed the most revisions, as it forced me to learn about all aspects of type design such as spacing. And although Toulon was used as running text in the college prospectus, generally I think it works better when used at large sizes, such as on posters."

Baines describes Hauser, another of his fonts, as "a nineteenth-century grotesque pattern with misalignment of vertical elements". He continues: "Hauser started with a bold, which was very loosely inspired by a street sign in Horncastle, Lincolnshire, and was developed in quite a self-consciously wrong way. The process of designing it began in 1992 and it was developed further on screen to a weird balance between properness and wrongness. The bold was done first because I love heavy Victorian grotesque lettering; I worked on lighter letters later."

Hauser was first used commercially on the publicity for the exhibition 'Pushing the Boundaries' and consequently Baines changed the misalignment, although this is only evident on the letters 'P', 'B' and 'R'. Says Baines: "I need commercial projects to provide a way to try my type out. I used both Hauser and Toulon in the Central Saint Martin's

HAUSER TYPEFACE, 1992–1995
BAINES STARTED DRAWING HAUSER BOLD IN 1992 AFTER BEING MOTIVATED BY A STREET SIGN HE'D SEEN AND PHOTOGRAPHED ON A VISIT TO HORNCASTLE IN LINCOLNSHIRE. THE SIGN WAS ENAMELLED STEEL WITH WHITE CONDENSED GROTESQUE LETTERS ON A BLUE BACKGROUND. LIKE MANY VICTORIAN AND EDWARDIAN GROTESQUES, THE LETTERS WERE HEAVY AND SLIGHTLY UNEVEN. THE WEIGHT AND THE UNEVENNESS WERE THE TWO IDEAS PURSUED IN THE FONT'S DESIGN, WHICH AT THE START ONLY HAD THE BOLD WEIGHT. THIS WAS FIRST USED IN 1993 FOR AN EXHIBITION AT CENTRAL SAINT MARTIN'S CALLED 'PUSHING THE BOUNDARIES'

WHEN BAINES WANTED A HEAVY FONT FOR VISUAL IMPACT. IT WAS ALSO USED LATER IN 1996 FOR THE COLLEGE'S PROSPECTUS, WHICH USED ONLY FONTS DESIGNED BY STAFF, STUDENTS AND GRADUATES OF THE BA GRAPHICS COURSE. A FEW LIGHTER CHARACTERS HAD BEEN TRIED OUT IN 1994 AND WHEN BAINES WAS COMMISSIONED TO DESIGN JOHN MAIZELS' BOOK *RAW CREATION* FOR PHAIDON PRESS IN 1996 HE LOOKED AT THEM AGAIN. BECAUSE THE BOOK FOCUSED ON THE WORK OF INSANE, MARGINALISED OR UNTUTORED ARTISTS, THE SELF-CONSCIOUSNESS OF THE LIGHTER LETTERS SEEMED APPROPRIATE AND ENOUGH OF THEM WERE DRAWN TO BE USED FOR TITLES THROUGHOUT THE BOOK.

prospectus with the result that the index of college sponsors was like a type sampler."

Hauser was next used for John Maizels' book *Raw Creation* for Phaidon in 1996, where the lightweight was developed for the book's title and chapter heads. Until then the type had been known as Horncastle. "Hauser was the artist whose work I used for the cover and he died just before publication so the type was renamed. The carefully studied irregularity of the face has the perfect 'ugliness' for the book."

Aside from type design, Baines also writes and takes photographs. He undertook the teaching of a type design project at Cal Arts in the US with the brief that the students had to produce something that had an outdoor function rather than be for print or need a complete alphabet. Aspects of lettering or signage have since featured in articles in *Eye* magazine (nos. 34 & 37).

"When working as a graphic designer, I only self-initiate elements if it is required or necessary, explains Baines. "They are not self-indulgent as they come about for a specific reason and have a point rather than purely being visual play. I like accidents and restrictions that force you to explore the design further so you develop new ways of thinking. Self-initiated elements don't necessarily make the design better, as the designer can become too close to it. Having done various bits of writing, it is vital that you respect the role of the editor and the opinion of ruthless friends: while some elements might appear perfectly obvious to you, others can't see the point you are trying to make. Also there is a danger of disappearing up your own arse. I much prefer to work collaboratively."

According to Baines, one of the main benefits of working beyond the brief is the control element. "With another piece I wrote for *Eye* on Barcelona, I was able, with the art editor's permission, to move the pictures around to make the text and the illustration 'flow' so it was ultimately presented in the form of a picture essay," says Baines.

With designer Andrew Haslam, Baines has recently finished designing and writing the book *Type & Typography*. Aimed at degree-level students, the text comprises basic language theory, history of type design and manufacture, and a 'how it works' section. According to Baines, "the whole project is self-initiated as we came up with the idea and the design for a series of books that looks at various design disciplines; the next title will be *Fashion*. The layout design features space for side stories and long captions with the intention that the design had to be clear and helpful to the reader. I believe that good book design requires an understanding of the text and that this should lead the design. We had a very integrated approach to the book."

He concludes: "There is quite a big gap between 'graphic authorship' and self-initiated work. I just do the work; I don't have to coin a phrase to justify it. With most jobs there is a fixed fee and if I feel that one of my fonts would lend more to the design then I will use it. It also gives me the impetus to develop them further."

nisation

riculum plans

s curriculum.
oth academic & practical
iip of Illustrators to the Industry.

king.

covering the Admission of
x 4)
Fodorova to report

5)

"When looking through my foundation course sketchbooks I see that the captions at the bottom of the drawings became increasingly bigger until they became the work."

!$0,-.01234
BCDEFGHI
STUVWXY
hijklmnopo

Manufactured with FontStudio® ©1998, 1991 RB Vista Company
Å¨ä

) Real-time project

Client: Central Saint Martin's Museum and Contemporary Collections and Gallery
Job: Typeface design and promotional material for 'Museum in the Making' Exhibition, 2002

November 2001

The Doctor typeface began life in November 2001 as a series of scribbles by Baines on the corner of an agenda in a staff meeting at Central Saint Martin's, where he teaches typography two days a week. His idea was to create a real stencil typeface rather than simply copying the 'look' of a stencil.

December 2001–January 2002

Baines explored the sketches further three weeks later on a long train journey and began digitisation soon after. Although there was no client deadline, the design came quickly. "I digitised it in January; three weights with common counters. It was done mainly in the evenings after paying work or teaching was over". He'd already been asked by Sylvia Backemeyer (head of the college's Museum and Study Collection) to design the publicity and installation for the exhibition 'Museum in the Making' due to open in April. In addition to being Baines' employer, the college is also a client, and this seemed an ideal opportunity to test the font.

DOCTOR TYPEFACE, 2002
LEFT AND FAR RIGHT SHOW BAINES' INITIAL SKETCHES FOR DOCTOR, WHICH WERE PRODUCED DURING A LONG MEETING AT CENTRAL ST. MARTIN'S. THE MIDDLE ALPHABET SPREAD SHOWS THE COMPLETE FONT AFTER DIGITISATION.

Phil Baines

2 Established designers

February 2002

When approaching poster design, Baines works from the principle that it must be eye-catching first, exploring ideas of a cerebral or humorous nature second. "Like many of the shows at the college, this contained very diverse work: from a Dürer woodcut to a fibre-optic installation. I thought the weight of Doctor would allow each letter to be used as a 'picture box' in Quark. That way the poster could be striking at a distance but have a lot of richness when seen close up, and the historical wouldn't put people off."

Sylvia Backemeyer liked the poster design and Baines then presented it to Head of College, Margaret Buck. "At the end of the day I have to sell my work to her," says Baines. "Luckily the only proviso she suggested was to change the colour of some of the poster's type – the college name – to make it link with the registered museum's logo. The exhibition was to celebrate the museum's registration, an important recognition of our work, which makes us eligible for further funding to add to the collections."

Although pleased with the printed work, Baines still had a point to prove to himself. To provide the large headings needed in the exhibition, he cut a set of stencils from waxed card and painted straight onto the wall, proving that the typeface actually worked as the stencil set he'd designed.

But why the moniker Doctor? "My colleague Catherine Dixon was sitting her PhD exam on the day we had the staff meeting," explains Baines, "so it seemed appropriate. And she passed!"

Doctor may be used in a book on signs that Dixon and Baines are currently writing and designing.

An exhibition to celebrate the registration of
Central Saint Martins
Museum & Contemporary Collections & Gallery

16 April – 24 May 2002

The Lethaby Gallery
Central Saint Martins College of Art & Design
Southampton Row, London WC1B 4AP

Open Monday – Friday 10am – 8pm
Saturdays 10am – 4pm
Closed Monday 6 May

⊖ Holborn 1, 8, 19, 25, 38, 55, 59, 68, 91, 98, 168, 171, 188, 242, 243, 501, 521, X68

THE LONDON INSTITUTE

All images are of items from the Central Saint Martins Museum & Contemporary Collections | Poster & typeface designs by Phil Baines | Printed by Ripping Image
Exhibition curated by Sylvia Backemeyer & Chris Wainwright

3

Revamp design
Michael Johnson
Mark Chaudoir
Studio Dumbar
Michael Bierut
Hans Dieter Reichert

Revamp design

This section considers how commercially successful designers manage to bring a level of authorship even to identity work. It is a frequent challenge for designers to rework an existing identity, often using elements from the original for continuity, while at the same time developing the design to say something fresh and contemporary about the client. The designers present case studies of jobs that they have completed with this brief and reveal how they revamped an existing symbol or identity and made it their own.

While it is a commonly held view that designers feel that client-led briefs limit their freedom or self-expression, these designers relish the tight corners that briefs put them into. None has a burning desire to be considered an artist. If anything, their overriding aspiration is to be seen as the originator of a unique and appropriate graphic language.

Pentagram New York's Michael Bierut discusses how he deconstructed the components of the identity of the New York Jets football team. Pentagram's brief was that it could do what it wanted, but without changing the logo, so, using the component elements, Bierut commissioned a typeface to be designed around it. As Bierut says, "it was a case of mining what had previously existed to bring it forward".

At the other end of the client scale, Bierut cites his work for Mohawk Paper as an example of a designer being in a position of editorial control. To catch designers' attention above the surfeit of paper company promotions, Bierut devised a magazine-format mailer that covered a breadth of contemporary issues. "I'm more interested in being an editor – a more self-effacing position in a way – than in taking a starring role to feature my own virtuosity. But I like to think that I started a trend towards improving content."

Gert Dumbar of the Netherlands' Studio Dumbar is careful to emphasise the importance of good collaboration when discussing authorship and big commercial projects. With his studio's work for large, corporate clients such as the PTT and the Salvation Army, Dumbar believes the project to be the author. However, in smaller, arts-based and self-initiated jobs such as *The Fly Opera*, he and his co-creators take on this title.

Like Bierut's New York Jets commission, Studio Dumbar's redesign of the Salvation Army's identity required a 'new graphic language', while retaining the symbol of the red shield that identifies the client across the globe. While the graphic language could be said to be self-initiated, Serge Scheepers of Studio Dumbar makes a distinction between authorship and design. "An artist produces his or her own subjective form and content; a graphic designer starts with specific content provided (in many cases) and starts there to think of the right form in an objective way."

Michael Johnson of London's Johnson Banks' believes that a strong idea behind the work can be considered the self-initiated element. "I just can't help searching for a real problem to solve, rather than simply making one up and hoping no-one notices the difference," he says. He believes that the "the main battle in design – between ideas and self-expression – has turned back to ideas for a while."

The work he talks about in his chapter varies enormously: from a redesign of the identity for Parisian cultural park La Villette and a global education drive for the British Council, to a totally personal and self-initiated poster against George Bush's environmental politics, which he later donated to charity organisation The Campaign Against Climate Change.

What unites these established and successful designers is a spirit of invention, whether it be visually- or ideas-driven. However, they recognise that this inventiveness is only valuable when it is both accessible and effective in the desired market. They think outside the brief to create a solution. As Michael Johnson says: "No client would dare or even think of handing me a word document and saying 'make a brochure out of this'."

The BBC's Mark Chaudoir, who redesigned the popular BBC2 identity, agrees: "I may work for a large corporation, but I always try to respond creatively to a brief. The sheer diversity of the BBC output allows for a lot of creative opportunities. There is still room to self-initiate elements. I like the diversity of work here as I can write out the idea, then direct, art direct, design, edit and do the audio."

Ultimately, the creative and commercial success that these designers have achieved is due to an in-depth knowledge of their craft, design history, the markets they work in, and an urge to solve clients' problems. They also find time to work on alternative projects that allow them to develop their command of other mediums and forms of communication.

Confidence gained from success is also invaluable when handling clients in order to produce effective work. Says Dumbar: "Don't listen to clients, because they are stupid. The key to success is to debrief yourself and your client in a modest way, as clients always agree to or want things that are totally wrong for them."

Michael Johnson of Johnson Banks, London

"The majority of self-initiated work is created by designers who are in danger of rapidly disappearing up their own arses," says Michael Johnson. "You have to be pretty jammed in a corner with no way out to self-initiate. I prefer to twist around original ideas to being a designer who creates my own content for a client."

An example of this is the work that Johnson Banks created for The British Council. The brief from the organisation was for Johnson to visit seven of the countries where the British Council has schools that teach English. Johnson had to gain a sense of what was involved in teaching and express this in his work.

Inspired by Bill Bryson's book *Mother Tongue*, Johnson took the theme of language and the idiosyncrasies of the English language by humorously explaining grammatical rules using bold pictures. Johnson spent a summer doing research nose-down in a pile of grammar textbooks. He eventually produced a series of posters, the size of ads on tube carriages, which filled the dead space in the classroom. "I hoped

that the posters would distract the young Malaysian students, whose main reason for being at college was to shag other students."

This commission followed a series of Branding Britain posters that Johnson Banks had created for the same client. As this project had taken up most of the budget, Johnson rejected the first creative visual ideas of commissioning photography or Victorian woodcuts and opted to use clip art instead. As part of this initiative, Johnson also created two classroom clockface designs; one shows iconic symbols of London such as The Spice Girls, Big Ben and a black cab instead of digits, while the other features the numbers spelt in full. In all, the job took seven months to realise.

A further commission that allowed Johnson to be sole creator of the idea was the identity for Kushti, an editorial and communications consultancy. Kushti was formed by two women who have experience in journalism, filmmaking, PR and branding strategy, and their brief to Johnson was to create an identity that would get talked about and win awards. Johnson was awarded the work as an old friend of one of the partners. "I pitched the whole concept around a photography-based idea of two women or ladettes running a business," says Johnson. "As Kushti means 'sorted' or 'OK' in colloquial terms, I investigated what it means for a twenty-first-century woman to be sorted."

Michael Johnson

bra|ssiere

Contractions A word shortened to make it easier to say. The British Council

a moose mousse

Homophones Words which have the same sound but a different spelling and meaning. The British Council

dog and bone

Cockney Rhyming Slang Slang, spoken in the East End of London. A word is replaced by rhyming words or phrases. The British Council

BRITISH COUNCIL IDENTITY FOR EDUCATION SECTOR, 1998
HAVING USED THE MAJORITY OF THE BRITISH COUNCIL'S
DESIGN BUDGET ON THE SUMPTUOUS 'BRANDING BRITAIN'
CAMPAIGN, JOHNSON HAD TO INVESTIGATE CHEAPER ROUTES
TO REALISE AN INITIATIVE TO AID TEACHERS IN THE BRITISH
COUNCIL'S NETWORK WHO TEACH ENGLISH AS A FOREIGN
LANGUAGE. JOHNSON TURNED TO CLIP ART TO HUMOROUSLY
EXPLAIN THE PECULIARITIES OF THE LANGUAGE.

"The resulting identity featured very strong and, for some people, shocking images that dealt with taboos such as masturbation and sex. For example, one execution shows a shopping basket containing a copy of the video *Beaches*, a cucumber and a bar of chocolate to illustrate a Kushti girl's night in, while another shows a Swiss Army knife that includes a cork screw, lipstick, nail file, bullet and tweezers. The client approved the best ideas and the photography was shot so that the scenes looked as real and legitimate as possible. The ruler, knife, weighing scales and the tape measure required a huge amount of retouching in Photoshop. Also, the identity set a precedent by having six logos, which echo the company's flexible working environment."

La Villette is a popular park in north-east Paris that was built in the early eighties. It is an avant-garde cultural centre that includes a science museum and circus. French design group Grapus devised the original identity for the launch of La Villette and Johnson was approached to update the design for the nineties, implementing the design for promotional material of varying formats. As with Kushti, the commission came through a friend with the brief that Johnson had to include the diminutive green triangle from the original identity and make the design more contemporary.

"This job is sponsor logo hell; not only do you have the triangle, but each piece of publicity has to feature loads of logos. Consequently, we made the triangle into a bar that can work on any size of print material, and the type is compressed Helvetica Caps. The client sends us photographic images of varying quality, which it wants us to use in posters and publicity materials for upcoming events."

For a poster to advertise a forthcoming circus, the client sent Johnson a picture of sardines. Johnson turned the sardines pink and green and created an image of an acrobatic circus from them. Says Johnson: "For La Villette, we visualised the ideas with a digital camera in order to get client approval and then got it shot properly. The layout looked very similar to the final photo."

Johnson teaches at Glasgow School of Art and his experiences of teaching there encouraged him to become more interested in conceptual work, what Johnson would term as 'me' projects. "Students' work seems to be getting more conceptual," he comments. "For example, four to five of the students I work with have undertaken projects looking at childhood memories, and one has drawn a map of her relationships throughout the education system. Although one could accuse them of 'worshipping at the altar of self-expression'."

"Last year I came back from examining and was very impressed by most of the projects, which were quite different from designing a Dorito's pack," he continues. "I got quite depressed about it when I considered how I'm just an insignificant poster designer. This experience directly inspired me to design my own piece of work, which didn't have a brief and wasn't for any clients. The result was a George Bush poster, which became a charity campaign against climate change."

"The majority of self-initiated work is created by designers who are in danger of rapidly disappearing up their own arses."

KUSHTI CONSULTING IDENTITY, LONDON, 2002
AS KUSHTI OFFER CONSULTANCY IN A WIDE VARIETY OF DISCIPLINES SUCH AS MARKETING, JOURNALISM, CORPORATE STRATEGY, PUBLIC RELATIONS, PUBLISHING AND BROADCAST, JOHNSON OPTED TO CREATE SIX DIFFERENT CORPORATE IDENTITIES FOR THE SIX DIRECTORS TO REFLECT THIS DIVERSITY. SPURRED ON BY A COMPLETELY OPEN BRIEF,

JOHNSON CREATED A SERIES OF PICTURE-LED, ORIGINAL COMPS TO PRESENT TO THE CLIENT. THE COCAINE SPOON ON THE ARMY KNIFE WAS REMOVED DUE TO A BAD ATTACK OF NERVES FROM THE COMPANY'S FINANCIAL BACKER.

KUSHTI

Jane Austin Big Cheese

Kushti Consulting
17–19 Bonny Street London NW1 9PE
telephone 0207 485 7440
fax 0207 482 3553
mobile 07989 953 938
email jane@kushtinet.com

KUSHTI

Liz Vater Big Cheese

Kushti Consulting
17–19 Bonny Street London NW1 9PE
telephone 0207 485 7440
fax 0207 482 3553
mobile 07779 228 969
email liz@kushtinet.com

KUSHTI

Lynne Thomas Medium Cheese

Kushti Consulting
17–19 Bonny Street London NW1 9PE
telephone 0207 485 7440
fax 0207 482 3553
mobile 07767 370 773
email lynne@kushtinet.com

Kushti

Jane Austin Big Cheese

Kushti Consulting
17–19 Bonny Street London NW1 9PE
telephone 0207 485 7440
fax 0207 482 3553
mobile 07989 953 938
email jane@kushtinet.com

Kushti

Liz Vater Big Cheese

Kushti Consulting
17–19 Bonny Street London NW1 9PE
telephone 0207 485 7440
fax 0207 482 3553
mobile 07779 228 969
email liz@kushtinet.com

Kushti

Lynne Thomas Medium Cheese

Kushti Consulting
17–19 Bonny Street London NW1 9PE
telephone 0207 485 7440
fax 0207 482 3553
mobile 07767 370 773
email lynne@kushtinet.com

LA VILLETTE IDENTITY, 2002
PIERRE BERNARD OF GRAPUS DESIGNED THE ORIGINAL
IDENTITY OF LA VILLETTE IN THE EIGHTIES (LEFT). JOHNSON
WAS INVITED TO REINTERPRET THE DESIGN FOR THE NINETIES
WITH THE STIPULATION THAT THE TRIANGLE MOTIF REMAINED.
FOR POSTERS TO PUBLICISE UPCOMING EVENTS, THE PARIS-
BASED CLIENT SUPPLIES JOHNSON WITH AN IMAGE THAT HAS

TO BE INCORPORATED INTO THE FINAL DESIGN. IN THE CASE
OF THE SARDINE CIRCUS, A PICTURE OF A SARDINE WAS
PROFFERED, BUT WITH THE SCISSOR FACE DESIGN, JOHNSON
UTILISED THE UNIQUE AND STRONG IMAGE THAT WAS SENT TO
HIM TO GOVERN THE RESULTING POSTER. THE TRIANGLE MOTIF
IS NOW FOUND IN THE IMAGE SHOWN, RATHER THAN
SUPERIMPOSED AS A LOGO.

Johnson found a picture of Bush on the internet and, in the Freehand program Autotrace, put the picture into the program. The application turns the picture into graphics and enables the designer to break up the picture into strata-like pieces, resembling a map. "I found the whole process really liberating" he says.

Johnson believes that the graphic authorship debate basically starts with students, the theory being that students are more empowered than professionals. "Ten years ago students were more interested in getting paid," he says. "Now I regularly have conversations with them about how they would cope with normal graphic design and their seemingly collective desire to produce ethical work. It would appear that all roads lead back to Tomato, which was the first company to do work for themselves and then sell it on. I see that the education system has not recovered from a company like Tomato saying 'sod problem-solving and let's do our own thing'."

"I think I've been perceived as the pluralist anti-Christ who hardly ever uses Helvetica," laughs Johnson. "But now students at St Martin's are ringing me up to show me their portfolio. If you've got first years at St Martin's who are interested in ideas as opposed to 'me' projects then the times are a-changing. Perhaps this is a sign that the main battle in design at the moment is ideas versus self-expression."

GEORGE BUSH POSTER, LATER USED BY THE CAMPAIGN AGAINST CLIMATE CHANGE CHARITY IN 2002
INSPIRED BY THE NUMBER OF 'ME' PROJECTS COMPLETED BY HIS STUDENTS AT THE GLASGOW SCHOOL OF ART, JOHNSON DECIDED IT WAS TIME TO DESIGN SOMETHING PURELY FOR HIMSELF. AS JOHNSON IS CONCERNED ABOUT CLIMATE CHANGE AND HAD THE DESIRE TO PRODUCE SOMETHING WITHOUT A CLIENT, HE DESIGNED THE GEORGE BUSH POSTER. THIS DESIGN LATER BECAME PART OF A CHARITY CAMPAIGN, ALTHOUGH JOHNSON ADMITS THAT HE HAD TO WAIT UNTIL WELL AFTER SEPTEMBER 11TH BEFORE HE SHOWED IT TO ANYONE.

BBC Promo Director and Designer Mark Chaudoir, London

Mark Chaudoir joined the BBC directly from the Royal College of Art in 1987, working initially in the News and Current Affairs department on *Breakfast Time* and *The Six O'Clock News*. He then transferred into the Main department working on *The Late Show* before moving into the Presentation Graphics team, where he worked on a vast diversity of projects ranging from idents, Christmas campaigns, major sporting trailers, a cinema campaign for Radio 4, and title sequences for *Points of View* and *Modern Times*.

The BBC2 channel identity, which shows the '2' in various memorable guises, was designed and launched in 1991. The astonishing impact it has had on the public was revealed in a recent poll, where the channel was rated as sophisticated, witty and stylish. The personality of the '2' has also spawned several fanzine-style websites for BBC2 obsessives.

Says Chaudoir: "A channel ident is the most effective way of presenting and branding a television company's image on screen. This involves a symbol/logo or letters animated in a dynamic or engaging way. The idents are used just before the start of programmes as continuity linking devices and to differentiate the channel from its competitors, both terrestrial and satellite.

A channel identity's biggest challenge is to stand up to repeated daily viewing when the television station wants it to last many years."

"Essentially the '2' is a simple sans serif numeral which has a lot of body, with enough flexibility to look both light and weighty, ethereal and dynamic. By modelling the '2' out of a wide range of materials, the '2' can take on a variety of personalities," explains Chaudoir. "The '2' also works well in print, where it is legible and distinctive. On screen it doesn't suffer from the danger of monotony encountered by the many stations that rely on one logo or limited animations. It is the sheer variety which makes it such a distinctive family of idents."

Specific idents are devised to herald 'theme evenings' or seasons of programmes, and these campaigns use the '2' in a less corporate way, as it is their job to lead into trailers for programmes.

In 1999 Chaudoir and fellow BBC designer Tim Platt were given the task of rebranding the existing BBC2 idents. The marketing department's brief was that the resulting sequence had to have the power to surprise. "Our job was to take a recognised symbol and create a new concept," says Chaudoir. "The strategy showed the ability to shift gear with a recognisable brand."

The designers first brainstormed ideas and then storyboarded the strongest ones. Initially

Mark Chaudoir

A BBC2 IDENTITY BY LAMBIE-NAIRN, 2001
THE BBC2 CHRISTMAS CAMPAIGN FEATURING GARY RHODES
AND JULIAN CLARY WAS PART OF THE CHANNEL'S ORIGINAL
DRIVE INITIATED BY DESIGNER MARTIN LAMBIE-NAIRN.

THE THEME WAS THEN CONTINUED INTO THE NEW MILLENNIUM
BY CHAUDOIR.

BBC2 IDENTITY BY MARK CHAUDOIR, 2001, LONDON
AS A SENIOR DESIGNER IN 1999 AND WITH COLLEAGUE TIM
PLATT, CHAUDOIR REBRANDED THE EXISTING IDENTS. THE
REBRANDING STRATEGY WAS VERY CULTURAL, LIFESTYLE AND
CONSUMER-LED, AND THE '2' EMERGING FROM THE WATER
WAS THE FIRST IDENT TO BE SHOWN AFTER THE MILLENNIUM.
THE PAIR WORKED WITH ASYLUM MODELMAKERS TO REALISE
THEIR BRIEF.

WORK IN PROGRESS FROM WINTER OLYMPICS BBC COVERAGE IDENTITY, 2001

THE WINTER OLYMPICS CAMPAIGN WAS CREATED IN 2002 AFTER CHAUDOIR HAD MOVED TO BBC CREATIVE SERVICES AS A PROMO DIRECTOR. THE SKETCHES REVEAL CHAUDOIR'S INITIAL APPROACH TO THE INITIATIVE, WHICH AIMED TO SHOW THE ACTUAL 'EXPERIENCE' OF A PARTICIPATING ATHLETE. THE TRUST THAT THE BBC HAD IN CHAUDOIR'S SKILLS AS

A DESIGNER AND HIS IMPLICIT UNDERSTANDING IN WHAT THE TARGET MARKET REQUIRED GAVE CHAUDOIR THE CONFIDENCE TO BE ABLE TO CONCEIVE AND PRODUCE THE SEQUENCE FOR THE WINTER OLYMPICS. THE COMMISSION ALSO OFFERED CHAUDOIR AN OPPORTUNITY TO PUSH HIS DIRECTING SKILLS FURTHER BY SHOOTING THE LIVE ACTION,

around 20 storyboards were produced, each using a single drawing or three to four drawings plus relevant photographs to illustrate the idea, and to reveal the lighting or materials for the '2' set.

Chaudoir and Platt presented their ideas to the creative director, the marketing department, the head of department and channel management. Once the ideas were approved, the budget and production schedule were prepared. Says Chaudoir: "The heritage of the channel idents is to be very creative. We tried to push things technically and creatively but retain the brand values, and tried not to alienate the fan clubs. So the fact that the identity was already out there was an extra challenge to try to live up to the standard."

Chaudoir and Platt worked with Asylum Modelmakers, the company responsible for producing the majority of the models for the idents over their 11-year history. It took six weeks for the models to be built and they were tested heavily.

Says Chaudoir: "As I work for a large corporation, I always try to respond creatively to a brief. The sheer diversity of the BBC output allows for a lot of creative opportunities. There is still room to self-initiate elements. Although I now work more as an art or film director, I still generate my own typography and logos."

In 2001, Chaudoir transferred to the BBC Creative Services department to become more involved in directing live action, but also to write

"As I work for a large corporation, I always try to respond creatively to a brief. The sheer diversity of the BBC output allows for a lot of creative opportunities. There is still room to self-initiate elements."

SKETCHES AND SCREENGRABS TAKEN FROM WINTER
OLYMPICS BBC COVERAGE IDENTITY, 2001
THE CLOSE-UP VIEWS OF THE ATHLETES' FACES EMPHASISE

THE DRAMA OF PARTICIPATION, ALLOWING THE VIEWER TO
PARTICIPATE VICARIOUSLY IN THE ACTION.

and art direct the graphics and concentrate on editing and audio. His most recent sequence was for the 2002 Winter Olympics.

The brief came from the sports marketing department and took two and a half months from briefing to completion. "The brief gave a good steer, and then I spent a lot of time brainstorming with my co-creator Paul Cushion," reveals Chaudoir. "The whole concept of the trail was to show the Winter Olympics athletes experiencing their individual sports. This was achieved by building specially constructed camera rigs, with mini digital video cameras attached. The rigs were strong yet lightweight, and in no way restricted the athletes' movements. Using these cameras we were able to get the reverse point of view of their faces but also their point of view. We experience the skeleton face and point of view going down the run, the ski jumper as he roars down the jump, and the ice skater as she was held aloft. We used an audio track utilising sound effects to enhance the 'Experience It' idea.

"I like the diversity of work at the BBC," he continues. "I can write the idea then direct, art direct, design, edit and do the audio."

"A channel ident is the most effective way of presenting and branding a television company's image on screen."

Gert Dumbar and Serge Scheepers of Studio Dumbar, The Hague/Rotterdam/Frankfurt

In 2002, Dutch design consultancy Studio Dumbar was shortlisted to redesign the corporate identity of The Salvation Army. A Christian church organisation, the Salvation Army is staffed by both professionals and volunteers and offers healthcare support and fund-raising initiatives. This established organisation, with a significant global history, was seeking a design consultancy to aid the repositioning of the brand both internally and externally. A further challenge was to utilise design to make the connection with the audience and potential employees.

The Salvation Army interviewed a few design studios and chose Studio Dumbar because of its previous work for institutions such as the Dutch post office PTT and broadcaster NCRV.

The client was keen to employ a design group that didn't have a problem working with a religious organisation and also wanted an equal and open relationship. Studio Dumbar, for its part, wanted the relationship to be both critical and constructive with the emphasis on 'living the brand'.

The brief was for the studio to create an identity that showed respect for the brand's heritage by featuring the red shield, which had both a high recognition factor and an international context. Consequently, the client didn't want to break from its past, but to move the identity on with a design that was contemporary, solid and reliable. Says Scheepers: "The design needed diverse, flexible profiles and a manual with clear guidelines so it would be easy to apply."

A three-strong team was formed at Studio Dumbar consisting of a business manager, team leader and designer. Regular meetings were held where ideas were presented to the client's head of communication and internal designers, and work was presented to the management when decision-making was required.

"We discussed the requirements internally a lot," says Scheepers. "We made a considerable number of sketches and spent a lot of time thinking of how we could make it simple to apply and how to save money. An example of this was producing envelopes with two windows as well as correspondence templates."

Studio Dumbar

SALVATION ARMY IDENTITY REDESIGN, 2002
STUDIO DUMBAR BROUGHT THE SALVATION ARMY SHIELD UP TO DATE (ABOVE RIGHT) WITH A 3D APPROACH AND A CHANGE IN TYPEFACE. THE APPROACH TAKEN AIMS TO CONTINUE THE HERITAGE CONNECTED TO THE SYMBOL BY USING A SIMILAR FORMAT AND COLOURS.

SALVATION ARMY IDENTITY REDESIGN, 2002

THESE STYLE STUDIES REVEAL HOW THE DESIGN WORKS
ACROSS THE CLIENT'S LITERATURE IN VARIOUS ENTITIES FROM

LOGO-BASED, THREE-UNITS-BASED, PERSPECTIVE-BASED,
CIRCLE-BASED AND TRIANGLE-BASED (NOT SHOWN).

"Studio Dumbar was asked how to solve the identity problem of one organisation with so many different divisions of expertise," he continues, "so our self-initiated element was to create a second layer in the identity to support the first layer of the red shield."

Firstly, the designers devised one abstract form principal for all profiles and a specific colour for each. They then created a specific form for each profile that was less abstract and featured specific colours: a pigeon represented the church; a star stood for social reactivation; a butterfly indicated youth projects; a funnel represented recycling, and so on. These elements were used as a second layer of identity as forms to build with, rather than as illustrations.

The use of design elements to generate an original graphic language for a client has been applied in several previous jobs produced by Studio Dumbar. In 1989 the Dutch post office PTT was privatised and renamed Koninklijke PTT Nederland or KPN, and the new company went to Studio Dumbar for its new identity. The brief was deceptively succinct: to produce a new house style from the basic elements of the PTT identity. The studio developed a logo family for the new holding company and its two subsidiaries, Dutch Post and Dutch Telecom. For the purpose of formal identification, the logos are applied strictly and uniformly – in the case of stationery and signs, for example. As the business of post and telecommunications is a major part of everyday life, encompassing objects such as telephone boxes, vehicles, buildings, and a rapidly growing range of electronic equipment, the studio developed techniques for applying recognisable identities to any two- or three-dimensional form.

In each case, the elementary shapes that form the logo – the circle and the square – are reapplied to the logo's underlying grid. On this principle of deconstruction, the house style can be adapted and applied to anything from a coffee cup to a railway train.

"And the PTT's cups and plates must be the most frequently stolen crockery in Holland," laughs Gert Dumbar. "A form language system such as this renders itself a visual chemical reaction. Also we created a manual of how it should be used and applied that could be given to other design groups who work for the PTT, so we gave them the key to this language."

When it comes to commercial jobs such as PTT and the Salvation Army, Scheepers sees that 'graphic authorship' should not be a goal in itself. "I think of us as specialists in visual communication – always having to play a significant role in what's happening in the upcoming field of interaction design. By being critical toward the brief, we give a client something extra or different from what they expected, or thought they needed. An artist produces his or her own subjective form and content; a graphic designer starts with specific content provided (in many cases) and starts there to think of the right form in an objective way."

SALVATION ARMY IDENTITY REDESIGN, 2002
STUDIO DUMBAR IS ALSO RESPONSIBLE FOR BOTH THE
ORGANISATION'S INTERNAL MAGAZINE AND THE WEEKLY

PUBLICATION, WHICH IS SOLD BY MEMBERS OF THE SALVATION
ARMY IN RESTAURANTS AND BARS IN THE NETHERLANDS.

Even voorstellen?
Uitdelen en toch overhouden
Stichting Leger Des Heils Welzijn- en Gezondheidszorg

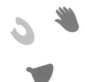

Karel Muller

Spoordreef 10
1315 GN Almere

T **036 53 98 111**
F 036 53 31 458

h.vtijlingen@legerdesheils.nl
www.legerdesheils.nl

Harm van Tijlingen
Adjunct-Directeur Stichting LDH
Welzijn en Gezondheidszorg

Spoordreef 10
1315 GN Almere

T **036 53 98 111**
F 036 53 31 458

h.vtijlingen@legerdesheils.nl
www.legerdesheils.nl

Jaap Kanis
Directeur Kerkgenootschap

Spoordreef 10
1315 GN Almere

T **036 53 98 111**
F 036 53 31 458

h.vtijlingen@legerdesheils.nl
www.legerdesheils.nl

Koos van Tijlingen
Directeur Stichting LDH
Dienstverlening

Spoordreef 10
1315 GN Almere

T **036 53 98 111**
F 036 53 31 458

h.vtijlingen@legerdesheils.nl
www.legerdesheils.nl

M 06 22 46 05 42

M 06 22 46 05 42

M 06 22 46 05 42

M 06 22 46 05 42

Studio Dumbar

3 Revamp design

SALVATION ARMY IDENTITY REDESIGN, 2002
THIS SERIES SHOWS STUDIO DUMBAR'S INITIAL AND FINAL
ICONS FOR THE CLIENT. THE DESIGNS REPRESENT WORK,
SOCIAL WORK, INITIATIVES FOR CHILDREN AND YOUNG PEOPLE,
CARE FOR THE HOMELESS, CARE, OFFICE, RECYCLING AND

INVESTMENTS. THE ARTWORK SHOWS BOTH AN ICON AND A
FINAL ICON IMPLEMENTATION STUDY. ALSO PRESENTED IS THE
USE OF LOGOS ON BUSINESS CARDS ACROSS ALL OF THE
CLIENT'S DIFFERENT DEPARTMENTS.

The Fly Opera was created for one of Dumbar's long-term clients, the Zeebelt Theatre in The Hague. "As opera has become so expensive and huge, I decided to stage an opera that made a joke of this megalomania. So I developed *The Fly Opera*, which obviously starred flies, and was very small and cost very little," he explains.

The production was subsidised by a tiny grant (60,000 guilders) awarded by the local arts council. Based on the Irish folk song *Molly Malone*, the street vendor who sold cockles and mussels in Dublin in the seventeenth century, the opera explores notions of selling and diminutiveness. As one of Studio Dumbar's main clients is the Ministry of Agricultural Affairs, Gert Dumbar was able to locate and work with a fly farm. The performing flies were animated by wires and dressed in tiny clothes. Dumbar also constructed miniature Bauhaus furniture for the sets. The set was based on five tiny monitors, each the size of

a shoebox, with binoculars for the audience. The opera could fit into the back of a van and toured the Netherlands, Germany and Belgium.

"The opera was also inspired by an article in a US magazine on psychological behaviour that revealed an experiment with three dolls' houses of descending size," Dumbar adds. "Those participating in the experiment had ten minutes to tell the history of themselves, like door-to-door salesmen. On average, participants spent 15 minutes in the largest fantasy house, 20 minutes in the medium-sized house and 25 minutes in the smallest house."

Dumbar says that the considerable number of design-literate clients in the Netherlands assists indigenous designers in their work. "As most Dutch clients are conscious of design, they buy into our culture and heritage more than, say, UK clients." Dumbar is less complimentary of the Dutch education system, feeling that it does not

"By being critical toward the brief we give a client something extra or different from what they expected, or thought they needed."

THE FLY OPERA, 1994
THE FLY OPERA FEATURED A SERIES OF SHOEBOX-SIZE SETS PRESENTING AN OPERA STARRING FLIES IN A LOOSE ANTI-CAPITALIST NARRATIVE.

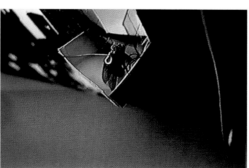

encourage a climate of enquiry and debate. He feels issues such as graphic authorship are, as a result, less considered by the young designers who will become the establishment of tomorrow. "Most designers go to art school in the Netherlands and when they fail at that, they become advertising people," he explains. "There is very little intellectualism in these establishments so very few are equipped or are interested in the notion. There is tremendous need for people who look further than their noses. I would say that with commissions such as the PTT and the Salvation Army, the project is the author. In the case of *The Fly Opera*, I, with some other enthusiasts like designer Bob Van Dijk and the Zeebelt Theatre collectively, am the author."

"An artist produces his or her own subjective form and content; a graphic designer starts with specific content provided (in many cases) and starts there to think of the right form in an objective way."

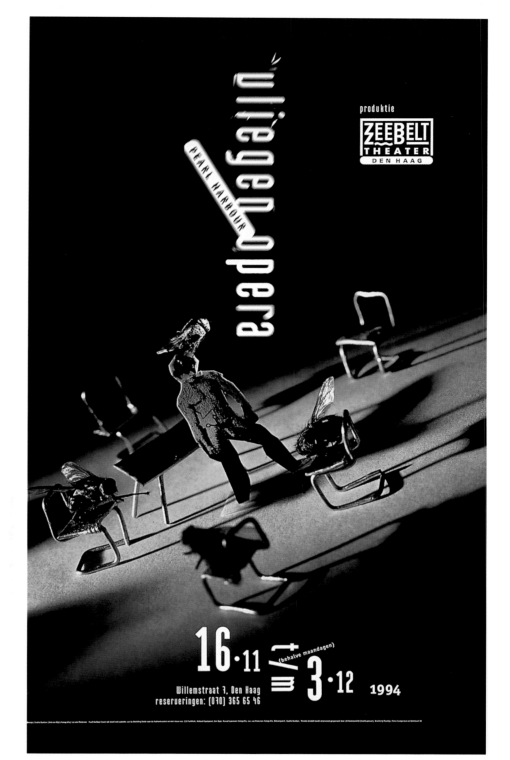

THE FLY OPERA, 1994

THE TRAVELLING OPERA WAS PUBLICISED VIA A SERIES OF
MINIATURE POSTERS THAT WERE PLACED ON THE PAVEMENTS
OF DEN HAGUE AND ON PUBLIC TOILETS – AS THESE ARE THE

PLACES THAT FLIES USUALLY HANG OUT. THE FULL-SIZE
POSTER SHOWS A SCENE FROM THE PERFORMANCE WHERE A
MALE FLY BECOMES A GIRL.

Michael Bierut, partner at Pentagram New York
In many cases, Pentagram New York partner Michael Bierut undertakes the opposite of self-initiation by identifying existing design and motivating the work further. "For instance, often I try to avoid doing a brand new logo for clients. It can be very hard for an organisation, especially a small one, to establish a brand new identity. It's hard for them to pick one, and it's hard for them to make their audience learn it. And often a great solution is lying there right under your nose."

He cites an example of an identity he recently created for a small institution, the New York Society Library. He lost the job in the first round but was approached by the organisation six months later as they had been unable to agree a new identity with their first designer. "The designer had worked for months to create a mark by setting the organisation's initials in a bunch of typefaces in all kinds of different configurations," Bierut explains. "But this work totally left the non-designers who use the facility nonplussed. After all, who is really interested in the difference between Futura and Garamond?"

Undertaking the project second time around, Bierut went back to something that had been ignored for years to gain an essence of the library. "Outside the front door was an old metal nameplate, supposedly designed by sculptor Paul Manship. It wasn't the kind of thing that I would have done," he says. "But I wanted to take the character of the writing the library users would recognise, as I saw no point in dispelling the connection with the history of the institution. So I created printed material building on this heritage."

Bierut also worked with existing elements to create a brand book for the football team The New York Jets. A team logo was designed in the sixties; "This design looked like some commercial artist had drawn it with cardboard and a ruler". It was under this logo that the Jets had won the Superbowl in 1969. Since then, however, the team's fortunes had fluctuated and it had become known as a hard luck team. In the seventies, the logo was 'updated', but predictably failed to improve the performance of the team.
In the nineties, a new coach, in a moment of desperation, decided to reinstall the logo from the glory days of the sixties.

Explains Bierut: "Our brief was that we could do what we wanted without changing the logo. So we took the logo as a compound and broke it down to

"Often I try to avoid doing a brand new logo for clients. It can be very hard for an organisation, especially a small one, to establish a brand new identity. It's hard for them to pick one, and it's hard for them to make their audience learn it. And often a great solution is lying there right under your nose."

Michael Bierut

THE COVER AND SELECT SPREADS FROM THE NEW YORK JETS POSTER, 2001
THE NEW YORK JETS STARTED IN THE EARLY SIXTIES WITH AN ANONYMOUSLY DESIGNED LOGO WHICH WAS RETAINED UNTIL 1978 (ABOVE LEFT), IT WAS THEN UPDATED IN 1997. LATER, A NEW COACH THREW OUT THE UPDATED LOGO AND RESTORED THE ORIGINAL LOGO TO REASSERT THE TEAM'S HERITAGE.

PENTAGRAM WAS ASKED IN 2001 TO WORK OUT A CO-ORDINATED BRAND LANGUAGE BASED ON THE ORIGINAL LOGO. BIERUT WORKED WITH EXISTING ELEMENTS TO CREATE A BRAND BOOK FOR THE FOOTBALL TEAM WITH THE HOEFLER TYPE FOUNDRY, DECONSTRUCTING THE ELEMENTS OF THE LOGO TO CREATE A FONT AROUND IT.

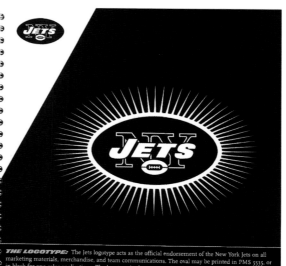

THE LOGOTYPE: The Jets logotype acts as the official endorsement of the New York Jets on all marketing materials, merchandise, and team communications. The oval may be printed in PMS 5535, or in black for one-color applications. The logotype is shown on a white background at the top of this page. Optionally, when placed on a colored background or over a photograph, the starburst may be included to add emphasis and draw attention to the mark. The starburst never appears in a color other than white.

CHANT COLORATION: Illustrated here is the full range of chant coloration options. The three basic colorations are: *full-color* (option 5), *infilled* (options 2, 4, 6, 9), and *outlined* (options 1, 3, 7, 8). Outlined versions may appear in PMS 5535, 390, 396, black, or white, with the interior of the letterforms left transparent to allow the background to show through. Infilled versions include: #2) 5535 infilled with a tint of 5535, #4) 5535 infilled with 396, #6) 5535 infilled with 390, and #9) 390 infilled with 396.

CHANT CONFIGURATION: This page illustrates the full and limited range of chant configurations. They are: #1) *vertical*, #2) *horizontal*, #3) *centered*, #4) *quad*, and #5) *single*. Artwork for all configurations is available in the color options shown on the previous page, except quad and single configurations which do not include the full-color option. Additionally, all configurations of The Chant can be "locked-up" with the Gameface mark as shown in #3. Artwork for these "lock-ups" is available as well.

EXPRESSIONS OF THE BRAND: Sample applications of brand identity elements and the guidelines defined in this manual are shown on this spread. As important as it may be to continuously find new and fresh ways to implement and expand the Jets brand, it is just as important to retain an element of continuity across everything produced, even when these items are made by different people in different parts of the world. Consistency is ensured when we work within the specifications of type and color, and when our marks and symbols are used where, when, and how they are intended. It is important to consider the medium in which the item is being produced and to be sensitive to materials and production processes. Variety and surprise can be achieved through the use of scale, style of photography and illustration, as well as meaningful and cleverly written copy. Paying equal attention to all of these should result in a consistent, but unique application of brand identity. This is how we build the Jets brand.

the constituent elements. We brought in Jonathan Hoefler and Tobias Freré-Jones from the Hoefler Type Foundry to design a whole typeface around it. We took the oval form to create supplementary logos that could extend the language of the basic logo into new uses. It was a case of mining what had previously existed to bring it forward."

Bierut worked again with the Hoefler Type Foundry on the signage for the Lever Brothers headquarters building in Park Avenue in Manhattan. The building was designed by Skidmore, Owings and Merrill in 1952, and was one of the first glass and steel skyscrapers in Manhattan. It was very difficult for Bierut to find a modern typeface circa 1952 and he wanted to avoid the obvious route of a sans serif. Bierut discovered a few signs around the building that had been designed by Raymond Loewy at the time of the building's construction. In the same vein as the aforementioned projects, he was keen to build on what already existed. "My process is what architects would call the conceptual approach. I take what is already there and reclaim it to extend the use of it. In this case I took the lion's share of the budget to give to Jonathan and Tobias to draw a typeface on the back of these signs," he says. "Consequently they drew up a full set of characters, now called Lever Sans." Completed in 2000, Lever Sans is all capital letters and is very thin. In time, Hoefler will be releasing it as a font. While Bierut did not self-initiate the typography of these redesigns himself,

he employed the same impulse found in self-initiating elements of design. The resulting work accents the typography, creating a minimal yet entirely original identity befitting the brand.

Bierut's work for Mohawk Paper Mill in 1983 however, challenged his remit as a graphic designer. Rather than taking existing elements, Bierut's process for this job was more as author or editor. "It's a requirement of paper companies that they have to have the graphic ammunition to sell their paper to designers," he explains. "Paper design jobs are perceived as being ideal projects, as the briefs tend to be very wide and the audience consists solely of designers. I'm more interested in the more self-effacing role of editor than in taking a starring role to feature my own virtuosity."

"Mohawk, a small, very good paper mill from upstate New York, needed a fall mail-out that made its paper look nice. So I created a design journal called *Rethinking Design* that was very self-referential. To stand out amongst the plethora of paper company mailers, I thought it would serve the business best if the content wasn't purely from Mohawk's point of view. The resulting editorial covered topics such as environmental issues, as designers are frequently overwhelmed by in-coming garbage," he continues. "My aim was to design something that wouldn't be thrown out so I created literature in the format of an 80-page journal, the first of a series of five. I selected

LEVER HOUSE, 2000
BIERUT WORKED WITH THE HOEFLER TYPE FOUNDRY ON THE SIGNAGE FOR THE LEVER BROTHERS HEADQUARTERS BUILDING IN NEW YORK. BIERUT DISCOVERED A FEW SIGNS AROUND THE BUILDING THAT HAD BEEN DESIGNED BY RAYMOND LOEWY AT ITS INCEPTION AND WORKED WITH HOEFLER TO CREATE A FONT, LEVER SANS, THAT BUILT ON THE HERITAGE OF THE BUILDING.

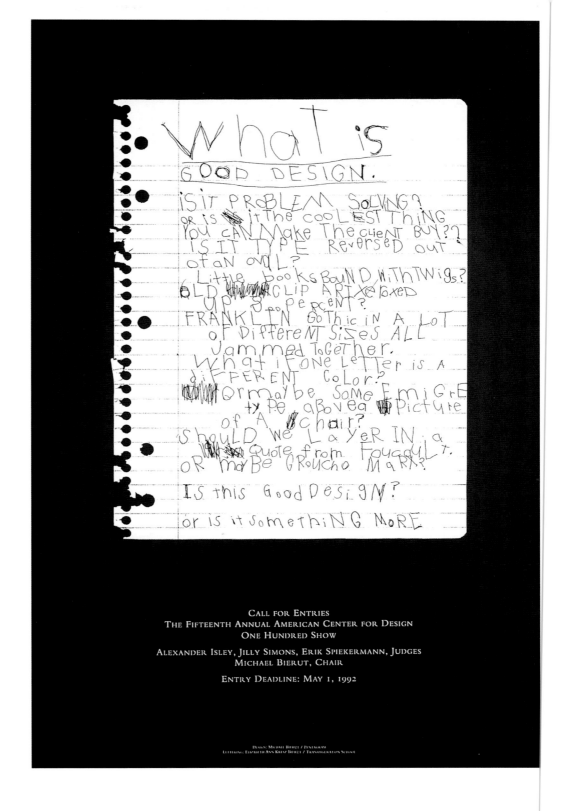

POSTER FOR THE AMERICAN CENTER FOR DESIGN, 1992
BIERUT'S FOUR-YEAR-OLD DAUGHTER PHYSICALLY WROTE THE
COPY ON THIS POSTER FOR THE AMERICAN CENTER FOR
DESIGN. THE NAIVE FORM OF HER HANDWRITING WAS DUE TO

THE FACT SHE HADN'T YET LEARNT TO READ, THIS GAVE THE
TONE OF THE WORK A UNIQUE AND TOUCHING EDGE.

RETHINKING DESIGN NUMBERS 1, 2, AND 3, 1983
PAPER COMMISSIONS TEND TO BE A DREAM COME TRUE
FOR DESIGNERS BECAUSE THE CONSUMERS CONSIST MAINLY
OF DESIGNERS AND THE BRIEFS TEND TO BE PRETTY OPEN.
FOR MOHAWK PAPERS, BIERUT CREATED A DESIGN JOURNAL
CALLED *RETHINKING DESIGN*, USING THE OPPORTUNITY TO

REPRODUCE SELECTED ESSAYS BY HIGH-PROFILE DESIGNERS.
BEIRUT INITIATED THE CONTENT, BUT CHOSE TO TAKE ON THE
ROLE OF EDITOR, RATHER THAN WRITER. THE EDITORIAL
CONSIDERED POLITICAL, ETHICAL AND THEORY-RELATED TOPICS.
DUE TO THE SUCCESS OF THE FIRST JOURNAL, BIERUT WAS
COMMISSIONED TO CREATE A FURTHER FOUR ISSUES.

essays by well-known writers and devised different designs for each piece. The work positioned Mohawk as a company for thinking designers, distancing the company from the huge amount of eye candy that designers get presented with. I would like to think that I started a trend towards improving the content."

Inspiration for a 'Call for Entries' poster for the American Centre For Design proved to be a stumbling block for Bierut, who was chairman of the jury. His brief was open but he wanted the design to reflect his concerns about design. "I had to have a theme," he says, "and wanted to question the roles of style, novelty and innovation. The challenge was how to do this in a way that, in effect, had no style. At the end of the day I dictated the text I had written to my four-year-old daughter and used her handwriting on the poster. Because she knew her alphabet but couldn't yet read, the lettering had a naivety that a professional designer couldn't simulate. The combination of the rather plaintive question with the handwriting of a four-year-old has a strangely touching quality."

Bierut claims to be very non-judgemental about the way design is produced, but he feels that there are two strains of graphic authorship in design. Firstly, he sees that there is a group of designers such as April Greiman, Massimo Vignelli, Ed Fella and David Carson whose work has a signature style. "These designers have a visual approach that is easily identifible and this way of working has, in effect, become a business card for them. It is also self-initiated by definition," he says.

"Graphic authorship is less about self-initiated projects and less about a sort of handwriting, but more about the concept and the purpose of content, where designers self-initiate the whole process," he explains. "Examples of this are Herbert Spencer's work and Bruce Mau's *Lifestyle* book. To a certain extent, the work I did for Mohawk falls into this category although it wasn't all about me. To create this sort of work, the designer has to find a client who will function as a patron and can cope with being revised and pushed."

Bierut continues: "The popular exhibitions that Charles and Ray Eames produced for IBM in the sixties were totally self-initiated. They made it possible for the technology to be explained to lay people while also playing to the designers' passions. Thirty years later, Tibor Kalman's work for *Colors* magazine revealed the same impulse and public spirit on behalf of the client – a global company producing sweaters with an attitude for multiculturalism that could transcend both the designer's interests and commercial goals."

But ultimately he sees that design journalists largely manufacture the 'graphic authorship' debate. "A lot of design critics set a goal or a manifesto for their next agenda that they think is about to burst upon the scene."

"Graphic authorship is less about self-initiated projects and less about a sort of handwriting, but more about the concept and the purpose of content, where designers self-initiate the whole process."

**Hans Dieter Reichert of HDR
Visual Communication, Kent**

For German-born designer Hans Dieter Reichert, the design process means more than putting something on paper: "It's a way of seeing life." Says Reichert: "Design is around us everywhere. Everything has been created, on purpose or by chance."

"I believe in design being honest, problem solving, sincere, purposeful and skilful and not about a quick catch, confusing, cheap and wasted, disposable, like 'fast food' products and ideas," he explains. "I'm interested in design and work that has thought, quality and lasting values. Consequently the work we are involved in is subconsciously in this vein."

The company's revamp of the identity of one of Germany's established jewellery manufacturers, Johann Kaiser (JK), based in Hainburg near Frankfurt, was truly a redesign with a difference. The overhaul of the company's image also resulted in the creation and launch of a daughter company, Anne Kaiser Werkstätten, with its own brand concept and product range.

Johann Kaiser's corporate identity had remained unchanged since its inception in the fifties. "JK asked us to analyse and review the existing image and recommend a way forward. We then created an elegant, more modern, but still classical visual identity. It was also important to signal a kind of openness and transparency to the dealership and customers," explains Reichert. "Our relationship with Johann Kaiser was one of mutual understanding. So while we were in the process of developing the new identity for the company, we realised (in order to widen the product range) that a separate company was needed.

"It would become important to create a daughter company which could consequently cater for an aesthetically and conceptually more aware and demanding existing and new customer."

Johann Kaiser's existing dealership realised that this new identity heralded a change in the company. Once the dealership had got used to the new visual identity, the management and HDR upped the ante by creating a further identity for the new daughter company, which would produce more design-orientated jewellery. Says Reichert: "We agreed to call the new company Anne Kaiser Werkstätten (AKW), to have a loose association with the early continental art and design

JOHANN KAISER

Hans Dieter Reichert

JOHANN KAISER IDENTITY REDESIGN, 1998–1999
REICHERT'S PROPOSAL FOR THE REDESIGN OF JOHANN KAISER'S CORPORATE IDENTITY (ABOVE LEFT) AND A SERIES OF EARLY SKETCHES FEATURED FROM 1998. TO RATIONALISE THE DESIGN CONCEPT, REICHERT PRODUCED A COMPANY AUDIT

AND PROPOSAL TO CLEARLY EXPLAIN HOW THE DESIGN WOULD BE IMPLEMENTED ACROSS THE COMPANY'S STATIONERY RANGE AND BROCHURES.

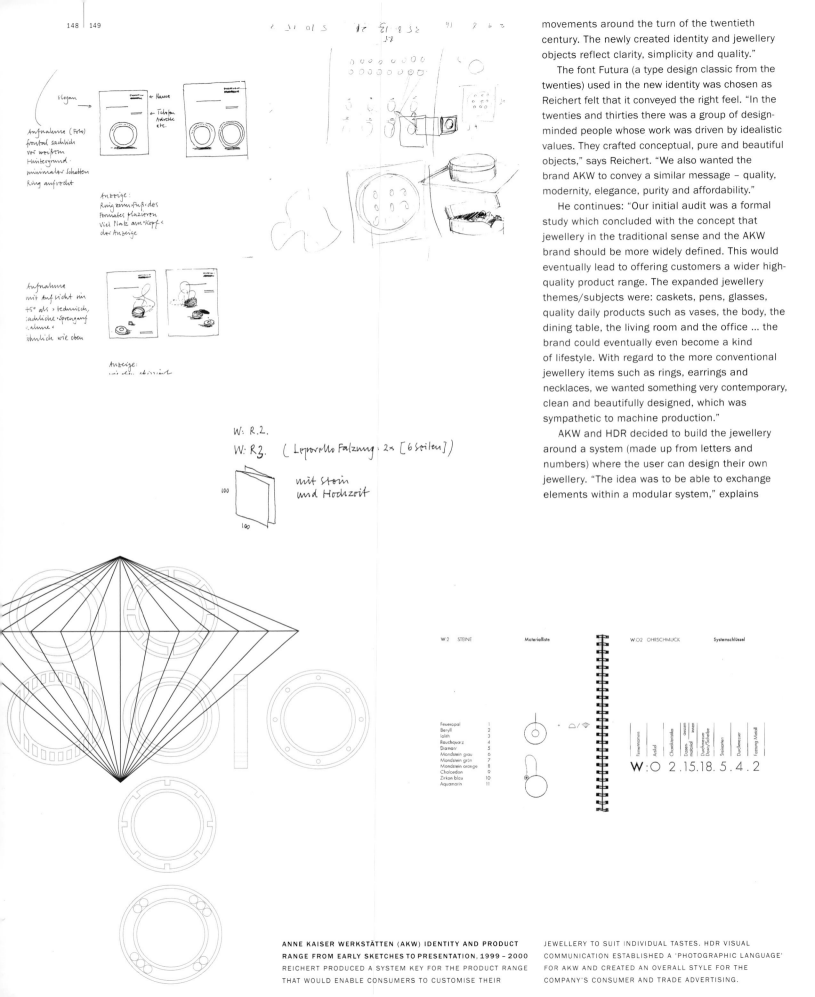

movements around the turn of the twentieth century. The newly created identity and jewellery objects reflect clarity, simplicity and quality."

The font Futura (a type design classic from the twenties) used in the new identity was chosen as Reichert felt that it conveyed the right feel. "In the twenties and thirties there was a group of design-minded people whose work was driven by idealistic values. They crafted conceptual, pure and beautiful objects," says Reichert. "We also wanted the brand AKW to convey a similar message – quality, modernity, elegance, purity and affordability."

He continues: "Our initial audit was a formal study which concluded with the concept that jewellery in the traditional sense and the AKW brand should be more widely defined. This would eventually lead to offering customers a wider high-quality product range. The expanded jewellery themes/subjects were: caskets, pens, glasses, quality daily products such as vases, the body, the dining table, the living room and the office ... the brand could eventually even become a kind of lifestyle. With regard to the more conventional jewellery items such as rings, earrings and necklaces, we wanted something very contemporary, clean and beautifully designed, which was sympathetic to machine production."

AKW and HDR decided to build the jewellery around a system (made up from letters and numbers) where the user can design their own jewellery. "The idea was to be able to exchange elements within a modular system," explains

ANNE KAISER WERKSTÄTTEN (AKW) IDENTITY AND PRODUCT RANGE FROM EARLY SKETCHES TO PRESENTATION, 1999 – 2000 REICHERT PRODUCED A SYSTEM KEY FOR THE PRODUCT RANGE THAT WOULD ENABLE CONSUMERS TO CUSTOMISE THEIR

JEWELLERY TO SUIT INDIVIDUAL TASTES. HDR VISUAL COMMUNICATION ESTABLISHED A 'PHOTOGRAPHIC LANGUAGE' FOR AKW AND CREATED AN OVERALL STYLE FOR THE COMPANY'S CONSUMER AND TRADE ADVERTISING.

Reichert. "The concept is beyond the traditional jewellery domain and comes with a system guide which allows the user to define what elements they want: metals, stones, sizes, finishes."

This information system also created the profile and branding for the jewellery. According to Reichert: "I kept the publicity and other visual information cool and understated, but elegant. It would have been mind-boggling to have individually named all the possible variations, since the available range is so comprehensive. In terms of graphic authorship, we helped initiate and contribute to the concept by widening the term 'jewellery', making it possible therefore for other products to be launched."

He continues: "The manual was created to give practical help, but also to give the system a kind of manifestation which helped the launch of the initial products. It is a rare situation where the design group is able to come in early and positively contribute to the design process. I would say that

Anne Kaiser Werkstätten produziert mit handwerklichem Können und zeitgemäßer Technik, innovative Schmucksysteme und Objekte. Anne Kaiser, Gründerin der Werkstätten, hat durch ihre Vision verschiedene Gestalter zusammengeführt. Unter Verwendung unterschiedlichster Materialien wie Platin, Gold, Edelsteine, Stahl und Nylon entstanden reduzierte, klare Formen und Körper. Dem Team von Anne Kaiser Werkstätten ist es damit gelungen eine neuartige Kollektion, mit einer Vielfalt an Möglichkeiten, im Rahmen einer ästhetischen Systematik zu entwickeln.

W:M
Zeitgemäße Medaillons, individuell zu bestücken mit persönlichen Dingen, die man am Herzen bewahren möchte, oder einer Vielfalt von gefassten Edelsteinen oder Colorit-Einsätzen aus dem Schmucksystem.
Gestaltung: Bettina Laduch

on this project we played the part of co-author with the client.

"My contribution as designer on this project was to help formulate the product palette and give it its face. I subscribe to the idea that the visual material should play part of a holistic approach: product, image and the design of the medium have to create a complete impression, down to the last detail."

Another of HDR's projects, *Baseline* magazine, is totally self-initiated as the "creation is within me". "It has become a business card for the company. I liaise and exchange ideas with internationally recognised contributors and produce, with the help of competent editorial designers, a high-quality product. *Baseline*'s concept is to communicate graphic matters. Its contents, design, material, printing and finishing is of a very high standard and has certainly helped me to get established in the publishing world," says Reichert.

Baseline is a quarterly typographic and visual magazine launched more than seven years ago with the aim to educate and cater for the visual communications field. It has an international circulation of 10,000. Reichert's premise is that the magazine shows historical and contemporary graphic design – not the latest design trends, but themes of long-term interest. "We want people to look at it, read it, keep it and use it as a reference source," he explains.

"I encourage my designers to create their own images and textures via mixed media."

BASELINE 37, 2002
INITIAL THUMBNAILS SKETCHED DOWN DURING CONVERSATIONS
ABOUT THE CONCEPT OF FRENCH TYPOGRAPHER/BOOK

DESIGNER ROBERT MASSIN. THE DESIGN SKETCH WORKS AS A
REMINDER WHILE THE DESIGN FOR THE ARTICLE, AFTER
SEVERAL REFINEMENTS, WAS TO BE FINALISED ON SCREEN.

in the static confines of the

...lap text
...in consistent with Massi...

"My aim is to engage people from the visual side first and thus encourage them to read the text."

Baseline aims to be a mirror of different aspects in contemporary visual communication, so there has to be a level of experiment in the magazine to reflect this. "I encourage my designers to create their own images and textures via mixed media," says Reichert. "*Baseline* doesn't have a rigid house style, although it has a grid system, which allows each story to be designed on individual merit. Despite this, some people say that they can see a certain style coming through."

Reichert regrets that the spirit of passion and agenda-setting that existed over 35 years ago, when Ken Garland wrote his 'First Things First' manifesto, escapes many designers and the way they work and the clients they choose to work with. "Consequently, graphic design is partly responsible for the plethora of visual pollution there is in our environment," he says. "So many young graphic designers think that they have to join a big consultancy rather than go in-house at a company that has a design pedigree. My aim is to engage people from the visual side first and thus encourage them to read the text."

ba**S**eline

international typographics magazine

No 36 | 2002 UK £11.00 Printed in England www.baselinemagazine.com

baseline is the authoritative and informative magazine about type and typography, within graphics and the visual arts. Published four times a year, *baseline* is internationally recognized for its contributors, contents and award-winning designs, which range from tradition to experiment.

Emil Ruder – typography from the inside — *Helmut Schmid*

Close Shaves and Razor Sharp Graphics — *Steven Heller*

The typefaces of Karlgeorg Hoefer — *Otmar Hoefer*

Designer – Printers — *Dr Caroline Archer*

'A reported story' — *Sam Winston*

Letters of Memorial — *Martin Andrews*

BASELINE 36 AND 37, 2002

THIS MATERIAL REPRESENTS VARIOUS TEXTURES THAT WERE COMPUTER-GENERATED, FOUND OR MANUALLY CREATED. THEY FORMED PART OF THE VISUAL RESEARCH BEFORE THEY WERE EDITED DOWN AND FINALLY SELECTED TO FIT THE CONCEPT FOR THE COVER/JACKET DESIGN AND INSIDE SPREADS.

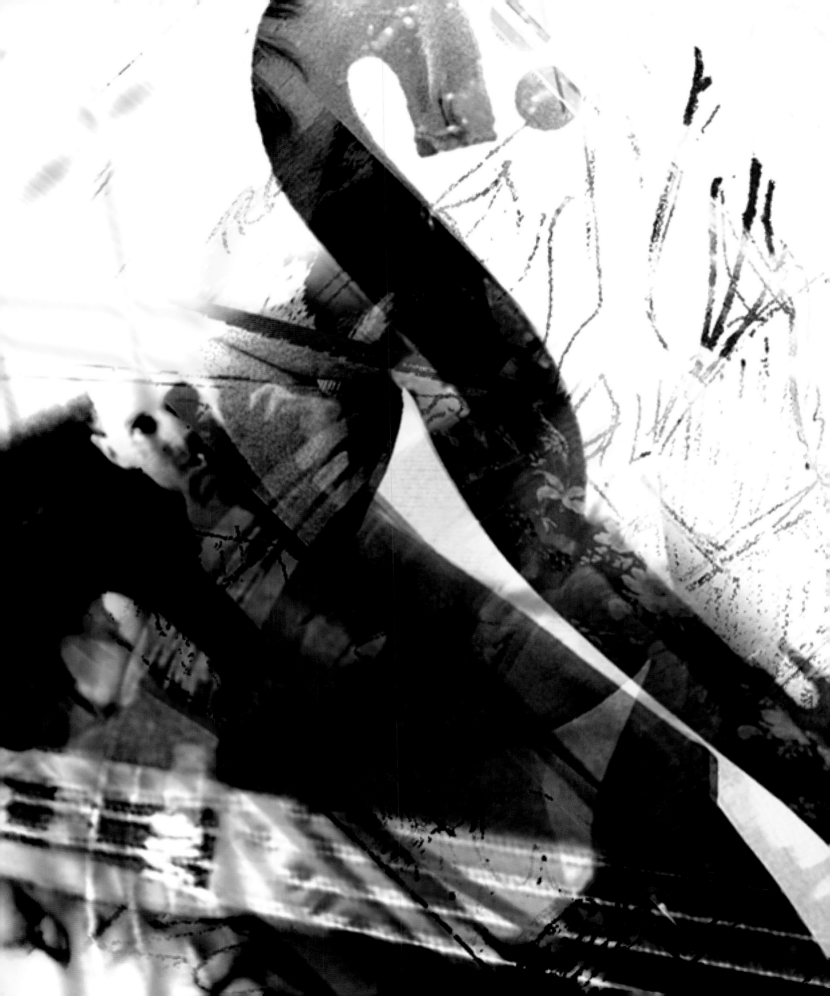

Aboud, Alan
alan@aboud-sodano.com
www.aboud-sodano.com

Baines, Phil
studio@philbaines.co.uk
www.philbaines.co.uk

Barnbrook, Jonathan
virus@easynet.co.uk
www.virusfonts.com

Bierut, Michael
bierut@pentagram.com
www.pentagram.com

Chaudoir, Mark
mark.chaudoir@bbc.co.uk
www.bbc.co.uk

Dunbar, Gert
dodo@dumbar.nl
www.studiodumbar.nl

Fanelli, Sara
020 7483 2544
c/o www.heartagency.com

Finney, Nick
n.finney@nbstudio.co.uk
www.nbstudio.co.uk

Goggin, James
james@practise.co.uk
www.practise.co.uk

Hegarty, Robin
robin@language.ie
www.language.ie

St John, Todd
info@huntergatherer.net

Hutchinson, Tim
bark@barkdesign.co.uk

Johnson, Michael
michael@johnsonbanks.co.uk
www.johnsonbanks.co.uk

Levin, Golan
golan@designmachine.net
www.sitedesignmachine.com

Manss, Thomas
thomas@manss.com
www.manss.com

Reichert, Hans Dieter
mail@hdr-online.com
type@baselinemagazine.com
www.hdr-online.com
www.baselinemagazine.com

Sagmeister, Stefan
ssagmeister@aol.com

Sorrell, Stephen
stephen@fuel-design.com
www.fuel-design.com

Sweeny, Niall
pony@btconnect.com

Tilson, Jake
jake@thecooker.com

Warren-Fisher, Russell
russell@rwfhq.com

Contact details

Thank you to those who contributed their work to this book; and thank you to Kate Noël-Paton, my editor at RotoVision, for her support and sense of humour. A big thank you must also go to the book's researcher, Joan Ingle. All my love goes to my daughter, Jess.

Acknowlededgments